W9-BEQ-140

W9-BEQ-140

FU JI TSANG THE MEANING OF FLOWERS

A Chinese Painter's Perspective

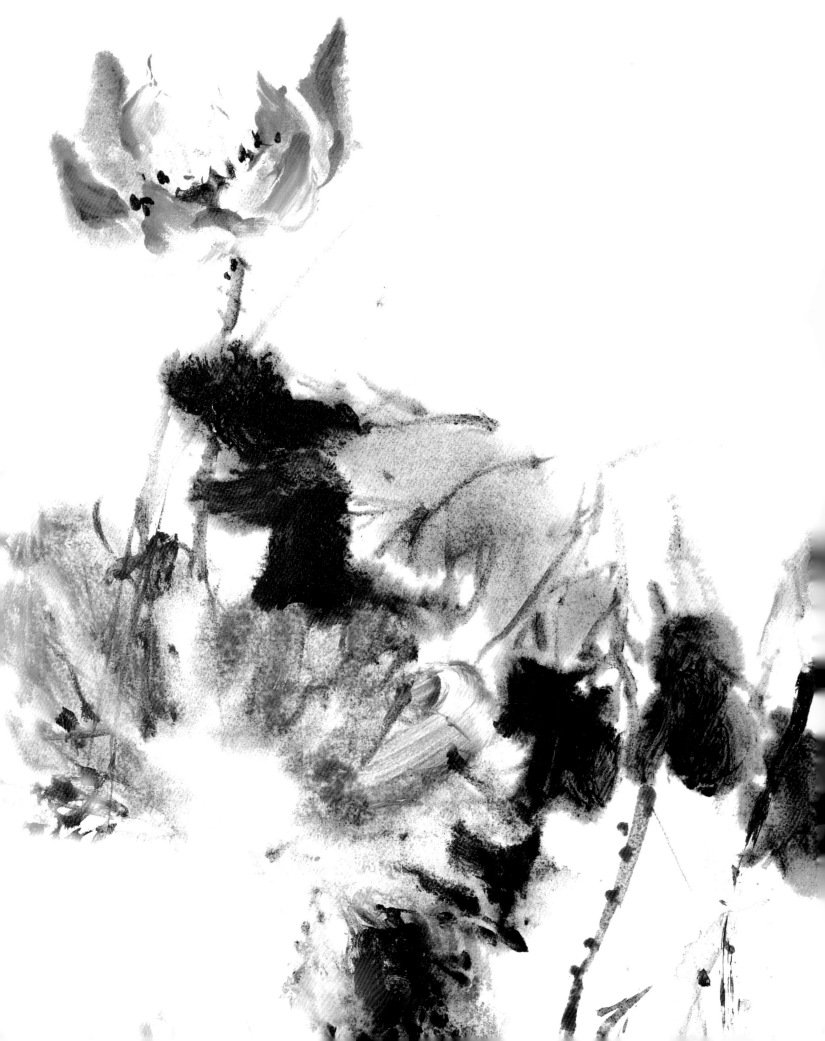

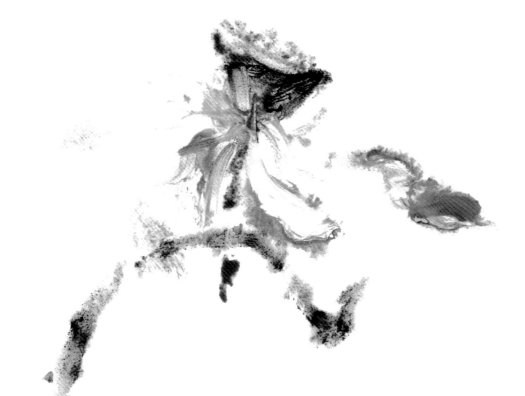

FU JI TSANG THE MEANING OF FLOWERS
A Chinese Painter's Perspective

Flammarion

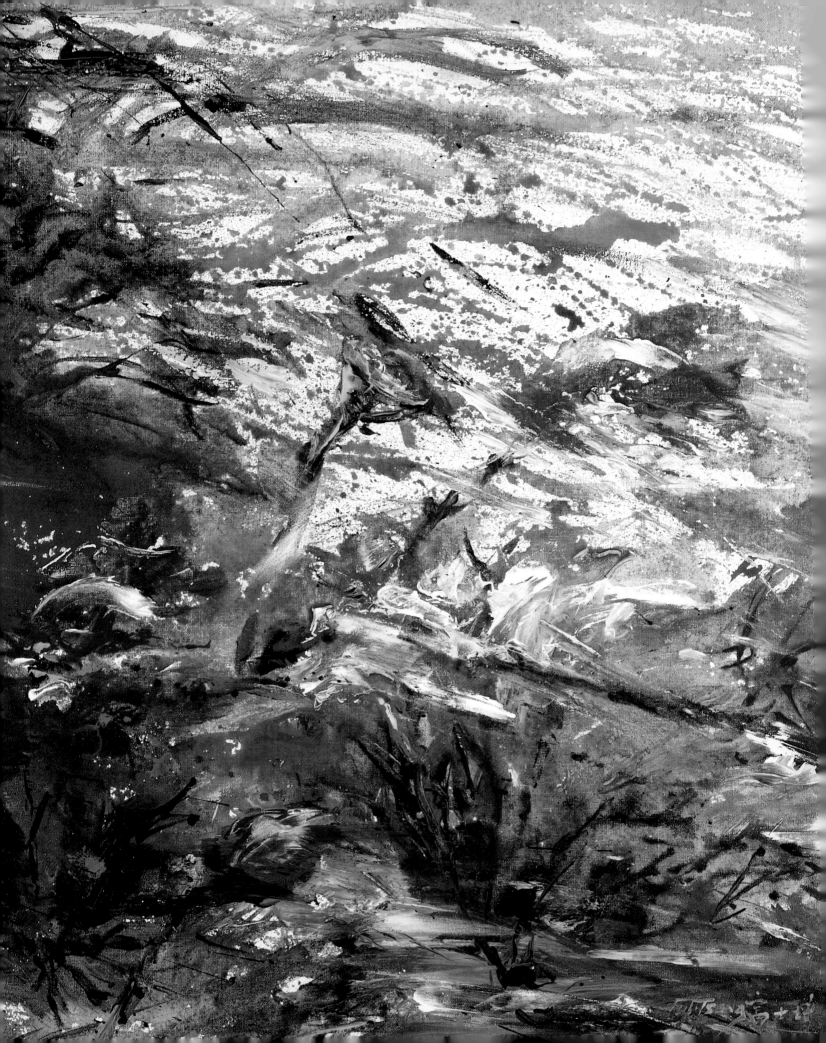

INTRODUCTION

A thousand clouds among a myriad streams
And in their midst a person at his ease.
By day he wanders through the dark green hills,
At night goes home to sleep beneath the cliffs.
Swiftly the changing seasons pass him by,
Tranquil, undefiled, no earthly ties.
Such pleasures!—and on what do they rely?
On a quiet calm, like autumn river water.

HAN SHAN
Translated from the Chinese by Peter Harris, *Zen Poems*,
edited by Peter Harris, Arthur A. Knopf, 1999.

MUCH MORE than mere decorations, flowers in art are endowed with a symbolic dimension. Artists do not paint flowers or trees simply for their beauty. They translate not only the physical aspect of the plant, but also their understanding of it. By transcending the concrete, the artist touches the notion of the sacred. In the East as in the West, the artist uses creative genius to reveal a multifaceted and unique reality. Some call this reality the "Primordial Breath," others call it "Nature's Soul."

In the East, art and human development were influenced by three schools of philosophy: Taoism and Confucianism—both Chinese in origin—and later Buddhism, imported from India via the Silk Road. Distinct in beliefs and practices, these schools of thought managed to influence one another while staying in harmony—a rare phenomenon in the history of humanity. Taoist thought situates the duality of material life in a cosmos that encompasses Everything to form a Unity. Its symbolism leads the Chinese to distinguish between feminine Yin and masculine Yang elements. For example, the mountain—a strong and rough natural element—is considered Yang, while the transparency and lightness of water renders it Yin. These two elements nevertheless shape one another: it is the height of the mountain that causes the water to flow downwards; as the water flows, it carves out valleys and sculpts the hardest rock to form the most spectacular reliefs. The Taoists consider this duality to be emblematic of life itself. Chinese painters accordingly name landscape painting *shan shui* (mountain and water painting). To illustrate and emphasize this concept, mountains and cascades are alternated in vertical compositions. Isn't it natural to dream of seeing what hides behind a looming mountain?

The Chinese believe that every element is inhabited by a soul. For them, a tiny pebble is a microcosmos of the whole universe in all its complexity. Buddha once said: "All the marvels of Mount Meru are contained in a mustard seed." This saying illustrates the idea of the infinitely small mirroring the infinitely large. In a Zen garden, seemingly strict and austere in appearance, the initiated can nevertheless perceive an abundant wealth where all of Nature is represented. An apparently ordinary element hides a more complex reality. On the contrary, a splendid-looking subject such as a flower is emptied of its true meaning if taken only at face value. In the twelfth century, under the southern Song dynasty, an interesting concept was proposed in the *Xuanhe huapu* (*Catalogue of Painters of the Xuanhe Period*): "Between Heaven and Earth, the Five Elements (Water, Fire, Wood, Metal, Earth) combine to form all things. The Yin and the Yang, the two vital Breaths, in turn give them life and enable them to interact with one another. When the Yin and the Yang breathe out, all things fade; when they breathe in, all things are restored. In truth, it is in countless trees and flowers that these Breaths come to life most vividly. From the depths of these trees and flowers spring forth all sorts of forms and colors, requiring no intervention from the Creator. Moreover, their magnificence adorns the whole universe; they inspire righteousness and harmony in the human spirit …"

Another key idea in Eastern thought is the Buddhist notion of the impermanence of life or constant renewal. This concept pervades the work of Su Shi, also called Su Dong Po, a high official of the Song court who is now less known as a statesman than as a painter and poet. Su Shi was exiled to the distant provinces where the poverty of the people had a great influence on his vision of life, as well as on his writing and art, the philosophical and humanistic dimension of which I find highly moving.

In the West, the symbolism of flowers took a different direction, evolving with changing artistic trends over the centuries. The ancient Greeks perfected the art of sculpture and frescoes where flowers were represented beside divinities to illustrate their qualities. In the Middle Ages, the Church encouraged painters to create a "pious language of flowers" where flowers were connected to symbols. In the seventeenth century, flowers played an important role in the Flemish school of painting. One of the masters of this school was Bruegel, who surrounded his works with garlands of woven flowers. In the eighteenth century, scientific developments led artists to represent flowers and plants in a more botanical, less soulful light. During the Romantic period of the nineteenth century, subjects were freed from their academic trappings. Delacroix emphasized the possibility of communing with Nature in all its irrationality and mystery. The strict description of reality gave way to the suggestion of intense, mystical or fleeting feelings. Courbet painted nature without seeking to conform to the Classicism of the past. Inspired by the transience

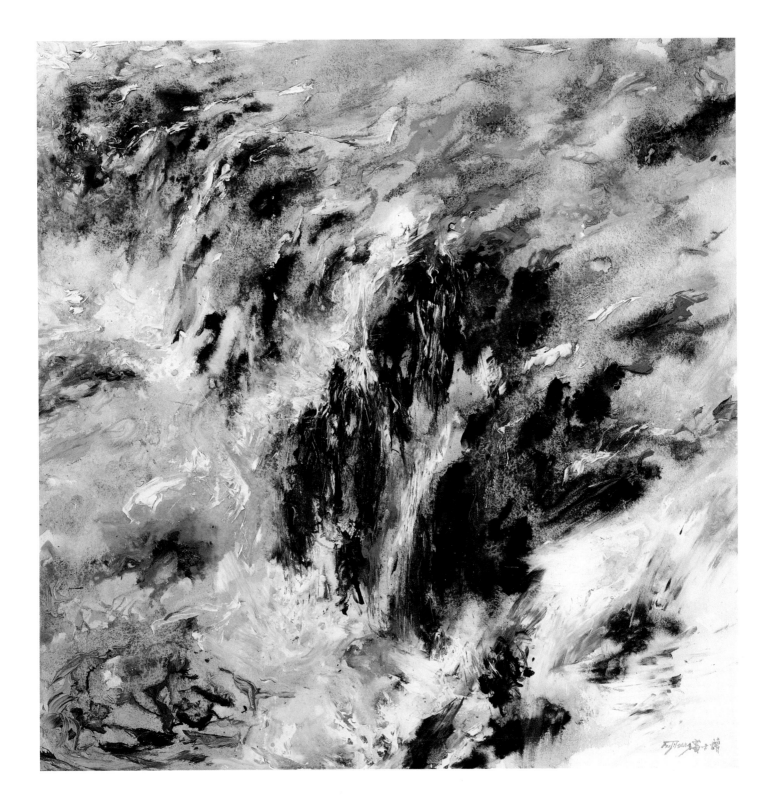

of Nature, Eugéne-Louis Boudin, one of the first European painters to work in the open air rather than in a studio, favored the unique atmosphere of a specific time and place. These artists were the precursors of the Impressionists, who combined a semi-scientific analysis of Nature with artistic intuition and inspiration. Closely linked to Boudin, Monet also painted outside to capture fleeting moments. His vision led him to create a series of works treating the same subject at different moments of a day or season. The secrecy and intimacy of Creation are contained in these seasonal and daily changes.

The twentieth century brought a greater introspection among artists. Remember that, according to Taoist principles, a seemingly ordinary element conceals an extraordinary complexity when the beholder knows how to observe it. Likewise, twentieth-century artists demonstrated an ability to provide highly personal interpretations of Nature. Eugène Delacroix wrote in his journal that "the more concrete a painter's work appears, the more intimate it is: for the artist, like Nature itself, clearly distinguishes between what is finite and what is infinite, that is, what stirs the soul in the objects striking its senses." In the same spirit, Cézanne sought to translate emotion not through a resemblance with nature, but through the images it conveyed to him. Gleizes and Metzinger give a remarkable explanation of his technique, similar to that of Chinese artists (*Du Cubisme*, 1912). Cézanne "teaches us to dominate the dynamism of the universe. He reveals to us the transformations that raw inanimate objects inflict on one another ... He prophesies that the study of primordial volumes will open up unknown horizons. Painting is not—is no longer—the art of imitating an object using lines and colors; it is the art of giving a visual conscience to our instinct."

Shortly before his death, Cézanne wrote: "Will I ever reach the yearned-for goal I have been seeking for so long? I thus continue my studies… I am still studying nature and I seem to be making slow progress." What humility is expressed in these words coming from a great founder of modern art who refused the Parisian artistic scene, preferring to live in contact with the elements— a vast subject of research and meditation.

Through this book and my paintings, I would like to lead others, as I strive myself, to seize the essence of Nature through Eastern and Western traditions, by blending with the past to better project into the future. Conscious that this may be the quest of a whole existence, I claim no more than to try to stir the interest of my readers and thus, according to the Chinese proverb, "cast a brick to draw marble."

A work should carry its whole meaning in itself and impose this onto observers before they are even aware of the subject.

HENRI MATISSE

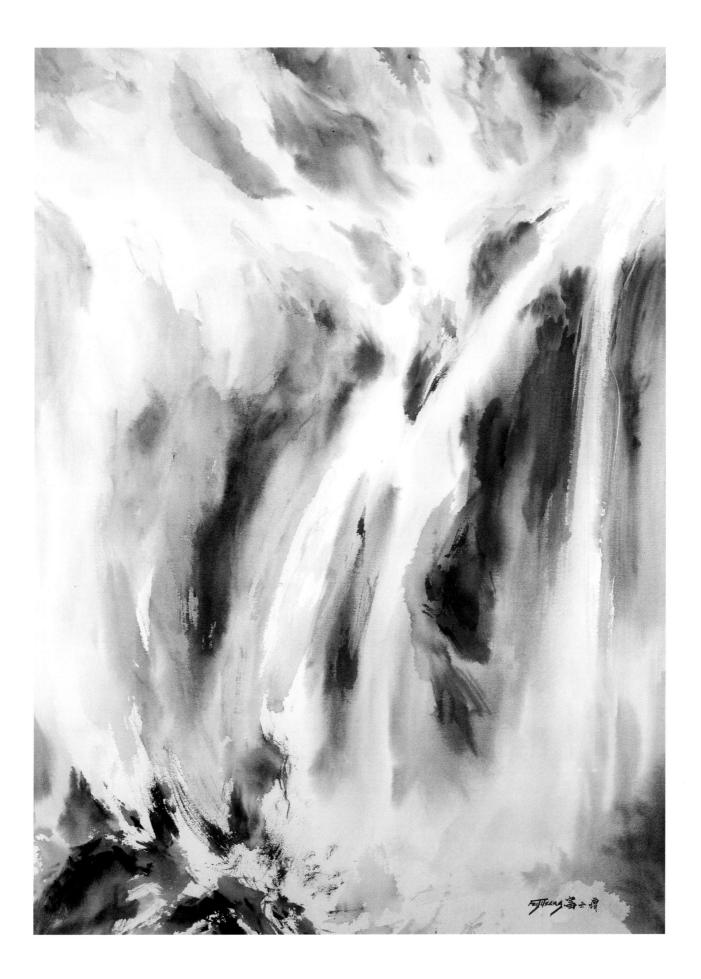

SPRING

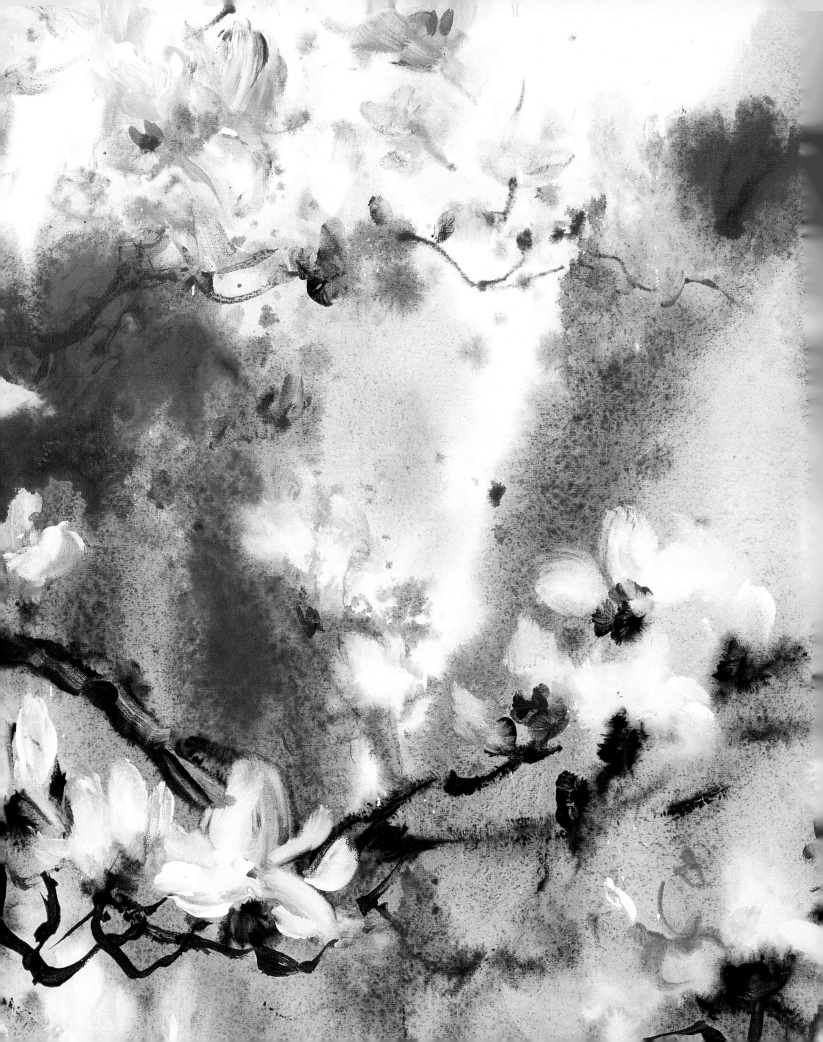

SPRING NIGHT

The few minutes of a Spring night
Are worth ten thousand pieces of gold,
The perfume of the flowers is so pure.
The shadows of the moon are so black.
In the pavilion the voices and flutes are so high and light.
In the garden a hammock rocks
In the night so deep, so profound.

SU DONGPO
Translated from the Chinese by Kenneth Rexroth, *Zen Poems*,
edited by Peter Harris, Arthur A. Knopf, 1999.

PEACH TREE

BAMBOO BRANCH SONG

The mountain's red with peach blossoms above;
The shore is washed by spring water below.
Red blossoms fade as fast as my gallant's love;
The river like my sorrow will ever flow.

LIU YUXI
Translated from the Chinese by Xu Yuanzhong,
Golden Treasury of Chinese Lyrics, Peking University Press, 1990.

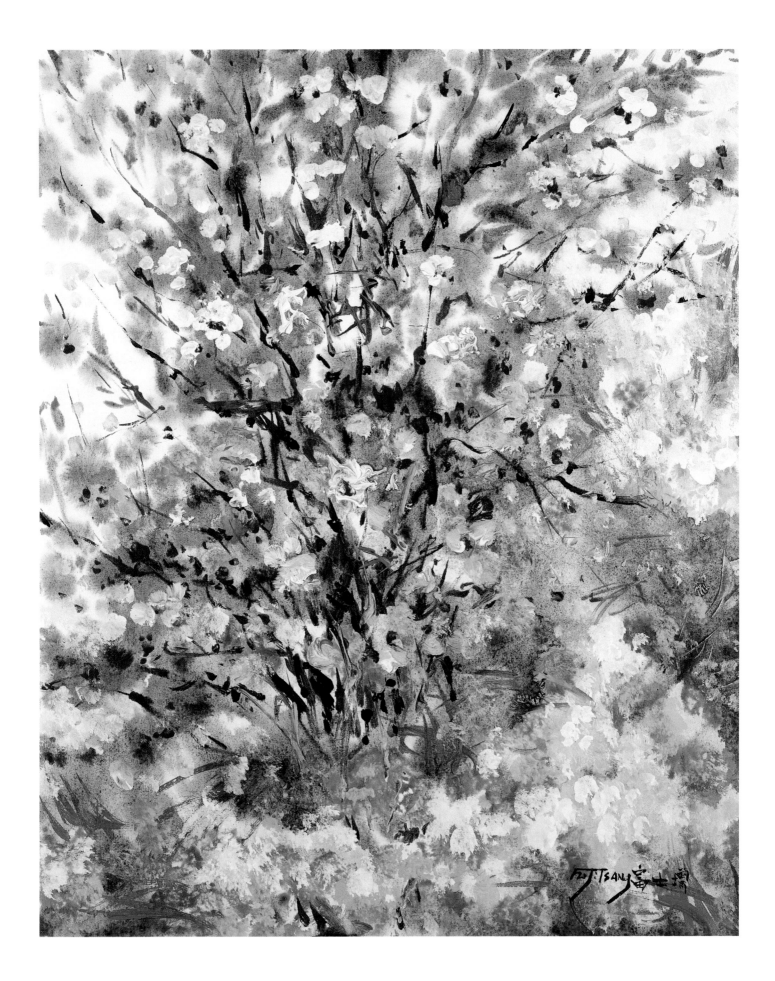

THE PEACH TREE, like the plum tree, belongs to the Rosaceae family. It is first mentioned three thousand years ago in the ancient Chinese Book of Songs, where poems praise the beauty of peach blossoms, with their coloring resembling that of a young girl's cheeks, as well as their sublime fragility and fragrance.

"… their coloring resembling that of a young girl's cheeks …"

IN CHINESE TRADITION, peach blossoms symbolize good fortune, while the fruit stands for longevity. The classic Chinese novel *Journey to the West* tells how each peach from the celestial orchard of the Empress Wanmu could bestow an extra thousand years of life to whoever ate it. One day, the heavenly Empress calls an assembly of the immortals and orders peaches to be gathered for the occasion. The fruit is, however, stolen and devoured by the Monkey King. The deprived immortals command a celestial army to capture the Monkey King, but in vain. In desperation, the immortals then summon the Bodhisattva Guanyin to discipline the rebel—an encounter that marks the start of the Monkey King's transformation into a hero.

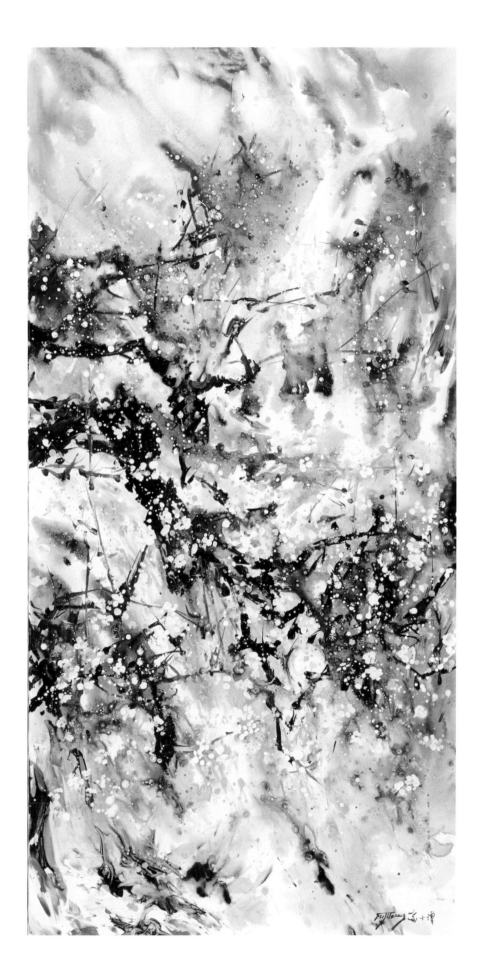

AZALEA

ALONE, LOOKING FOR BLOSSOMS
ALONG THE RIVER

The sorrow of riverside blossoms inexplicable,
And nowhere to complain—I've gone half crazy.
I look up our southern neighbor. But my friend in wine
Gone ten days drinking. I find only an empty bed.

I don't so love blossoms I want to die. I'm afraid,
Once they are gone, of old age still more impetuous.
And they scatter gladly, by the branchful. Let's talk
Things over, little buds—open delicately, sparingly.

Du Fu

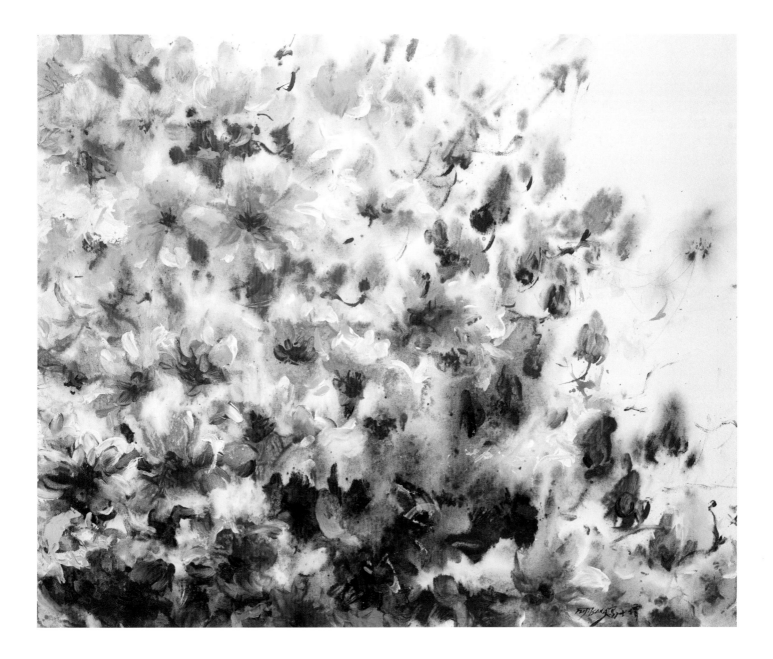

THE AZALEA, along with the gentian and the primrose, are known as "the three famous flowers" in China. In China, Cuckoo is the nickname given to the azalea whose flowering coincides each year with the cuckoo's song. Legend has it that a spurned lover, transformed into a cuckoo, returns each spring to sing its sad melody—a song so long that blood flows from the bird's beak, thus giving the azalea its scarlet color.

IN SPRING, azaleas in Chinese gardens bloom in colors as varied as those on a painter's palette, creating the impression of a whirlwind. I have a vivid memory of the thousands of flowers that make up an extraordinary composition at the entrance of the Humble Administrator's Garden in Suzhou.

"… azaleas in Chinese gardens create the impression of a whirlwind."

CLAUDE DEBUSSY, the French musician and friend of the Impressionists, was inspired by the melody of a Chinese round to compose "Sur le lac bordé d'azalées" ("On the Lake Surrounded by Azaleas") for piano and voice. Every time I hear this music, images of Chinese gardens spring to my mind. Debussy succeeded in conveying a unique ambiance where, as in travelogues, calm and intimacy are intertwined. The imagination joins forces with reality and so renders it sublime. I wanted to try the opposite experiment: that is, to paint the theme inspired by Debussy's composition. Listen to the music, by looking at my compositions!

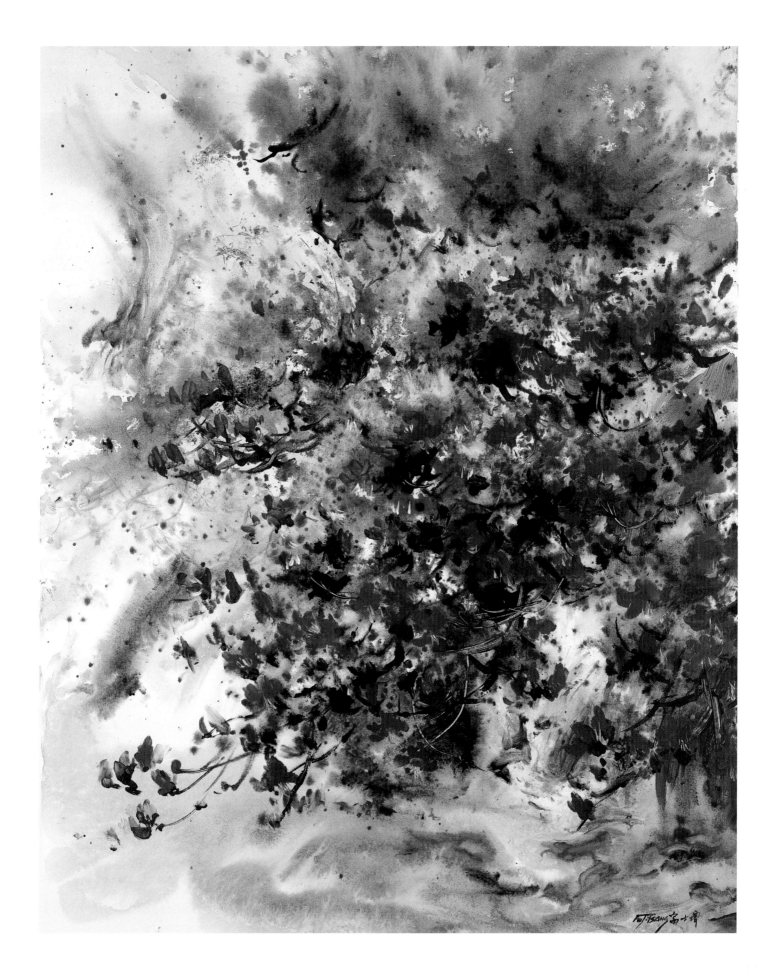

PEONY

PEONY PETALS

Three peony petals
Red like a peony
These petals cause me to dream
These petals are
Three beautiful little ladies
Silky-skinned and blushing
With shame
For being with little soldiers
They walk in the woods
And chat with the starlings
Who write sonnets for them

GUILLAUME APOLLINAIRE, *Poems for Lou*

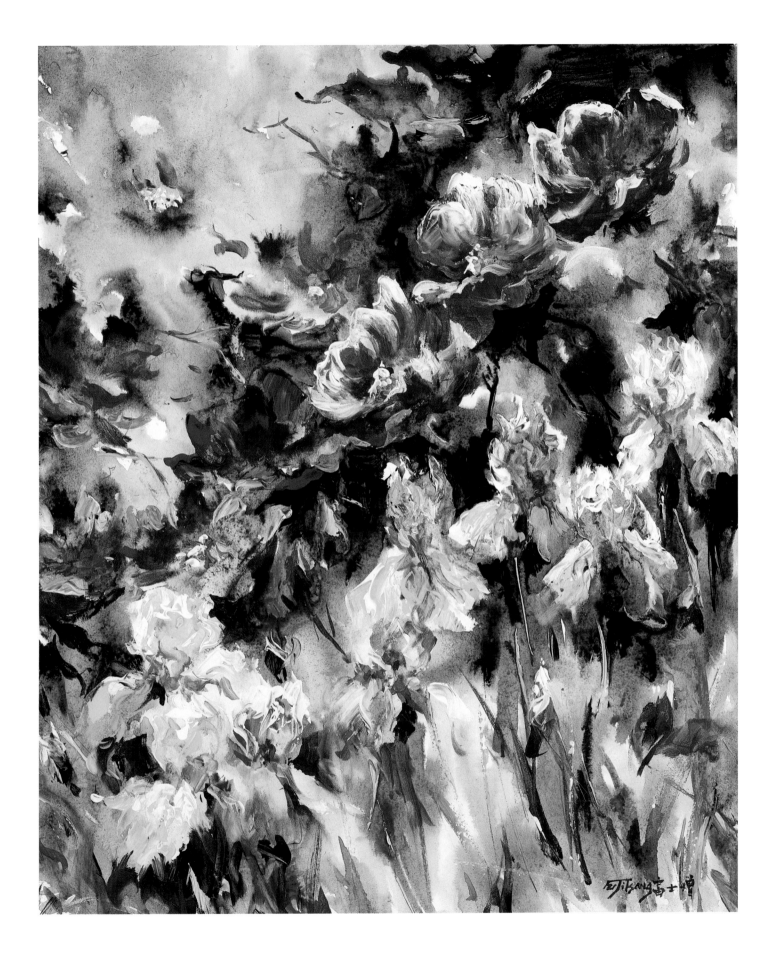

THE PEONY is much appreciated by the Chinese for its brilliant colors, full form, sophisticated and heady perfume, and fragile appearance. For the poets of old, it represented an inaccessible and ever-changing beauty. If there were a queen of flowers, in China she would no doubt be the peony. In the silk paintings of the Song court, the peony appears next to pine trees, the symbol of masculine longevity. The women of the court liked to place peonies in their hair to bring out their beauty. More than a thousand varieties of peony—an obligatory element of imperial gardens— are to be found in the gardens of the Forbidden City or the Summer Palace in Beijing.

"The peony is a symbol of happiness and I like to paint this flower when I am happy."

PRIZED AS A MOTIF in handicrafts, the peony—sculpted or pearl-encrusted—adorns ivory, jade, cloisonné work and lacquered furniture. Brought to France by missionaries in the eighteenth century, it was adopted at court in the royal gardens of the Versailles Palace, then copied onto wallpaper and porcelain vases.

Manet, the Impressionist painter, was fond of this flower, which grew in his garden in Gennevilliers and which figures in a number of his works.

THE PEONY is a symbol of happiness and I like to paint this flower when I am happy. When I settle before a patch of peonies, the fragrance of the sinewy and often double-layered petals invades me gradually, inspiring and guiding me. I paint almost instinctively. Time passes like in a dream from which I wake, shivering, when evening falls. On the canvas, several petals testify to a fleeting moment. Only my sketch keeps a trace of the faded flower, its ephemeral beauty. I have the impression of glimpsing the happiness and sadness of a lifetime …

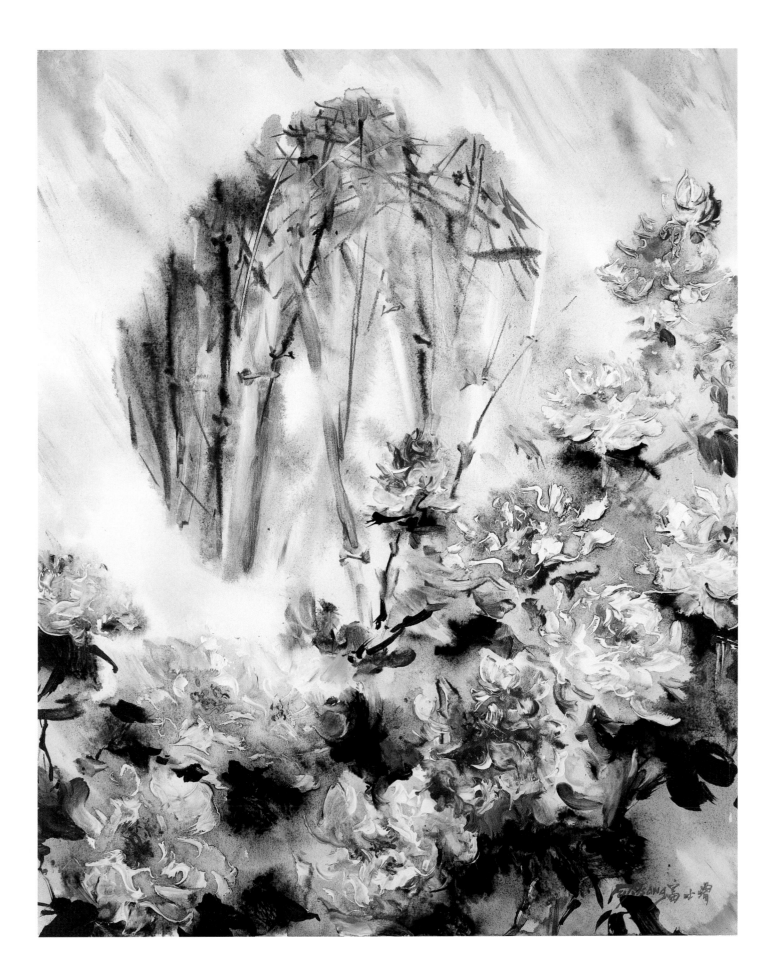

IRIS

There I also have a marvelous garden with many flowers that, for me, represent the best color compositions. When I see flowers, I have the impression that their colors are indelibly imprinted on my retina, as if branded by a hot iron. So if one day I find myself before a composition with a palette in hand and only a very vague idea of what color to use first, this memory rises within me and comes to my aid, inspiring me.

HENRI MATISSE

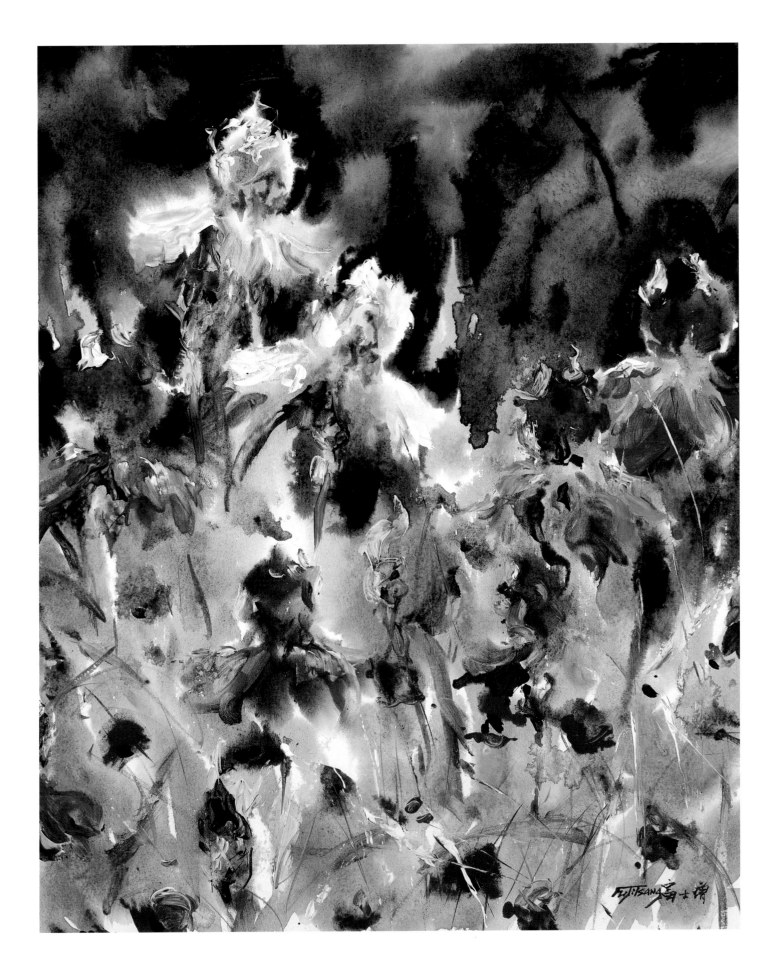

IN GREEK MYTHOLOGY, the goddess Iris, divine messenger, wore a veil composed of pearls of dew that reflected all the colors of the rainbow. This explains why "iris" is also the name given to the colored part of the eye that responds to different levels of light. The classical masters taught us that by half-closing our eyes, we can filter light and eliminate superfluous details to focus only on essential masses and volumes. This technique allows for a global vision of the subject and gives coherence to a composition.

I RECALL the marvelous garden in Fayence belonging to a friend, a great iris-lover. This terraced garden, bathed in a gentle light, is covered with irises of all colors that bloom in the shade of hundred-year-old olive trees. The fragrance of flowers and the song of cicadas float in the air. A feeling of peace reigns here. I fell under the spell of this garden, as if, coming across the goddess Iris, she had bewitched me. How do I translate my emotion and these vivid yet subtle colors, when the hues of my palette seem comparatively dull? How do I suggest the depth of the landscape with all its mystery?

"The iris is a rainbow flower!"

THUS I DECIDED to free myself from techniques and start all over, like a beginner. I used ink and chose a smaller subject so that I could concentrate on one element at a time. Then I moved on to using color— not to imitate reality, but so as to suggest and sublimate the beauty of this flower, as if in a dream. I imagined myself before a rainbow, a natural phenomenon that combines the real and the virtual. The iris is a rainbow flower! As a lover of color and light, I am happy when my compositions come to life. It is then that they become an exaltation of Nature.

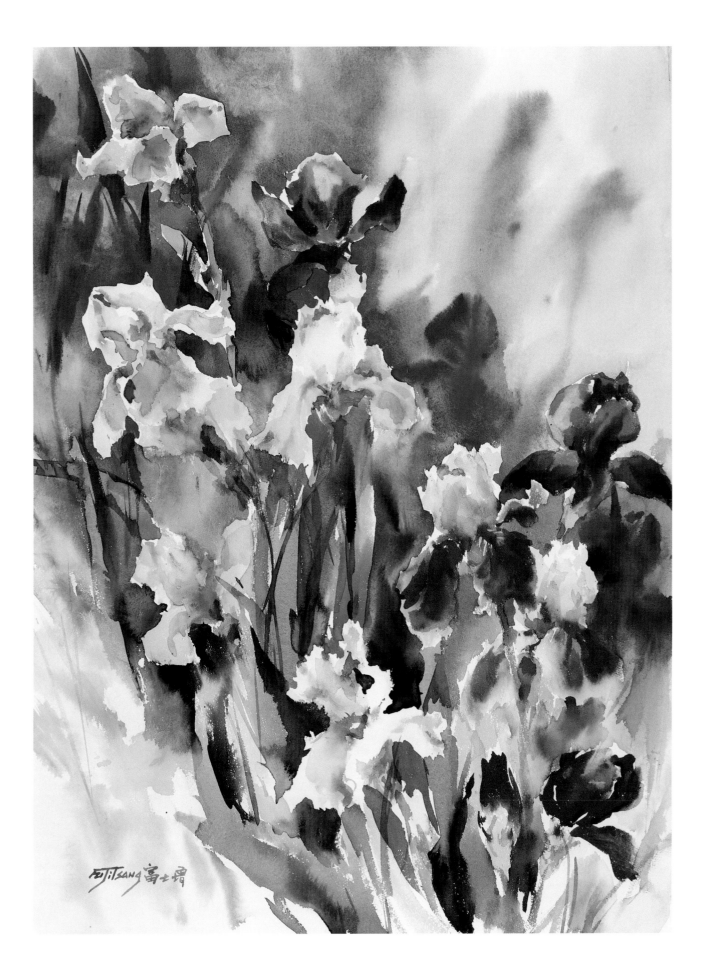

WISTERIA

FROM MIDDLE CHÜN-CHI HALL I CLIMB THE MAIN PEAK OF T'AI-SHIH MOUNTAIN

I stop the carriage facing the green cliff,
The climbing wisteria knows no fatigue!
People are coming from beyond the trees,
The road spirals up towards the clouds.
Suddenly I feel the fog and the rainbow;
I look back and the peaks are all transformed.

MEI YAOCHEN
Translated from the Chinese by Amitendranath Tagore, *Moments of Rising Mist*:
A Collection of Sung Landscape Poetry, Grossman Publishers, 1973.

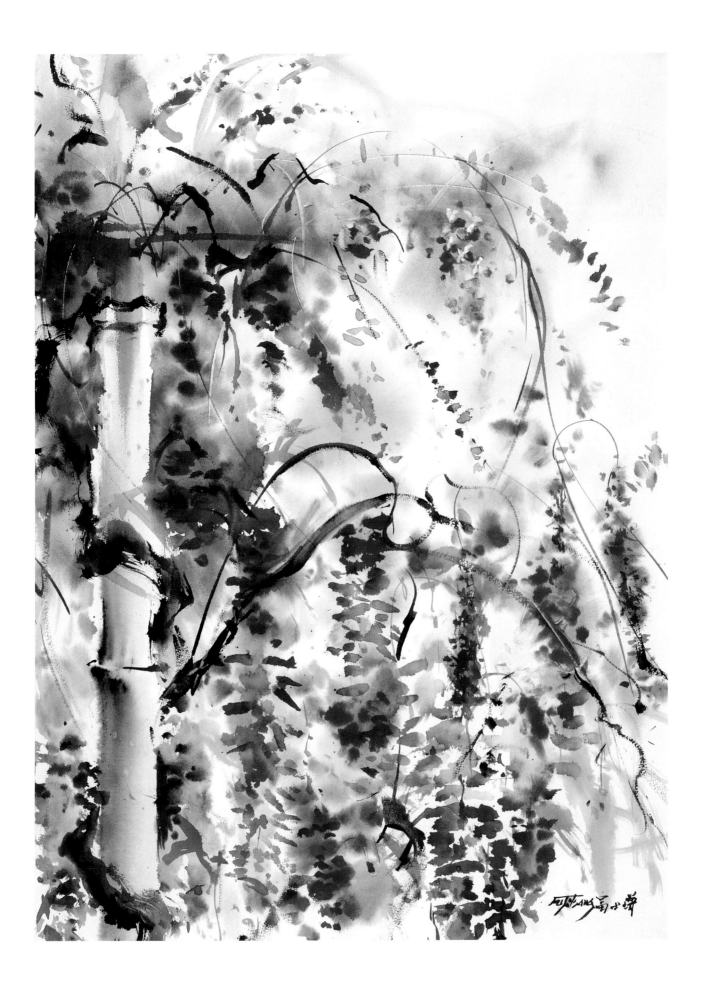

WISTERIA makes me think of Claude Monet and his garden in Giverny, which I discovered one spring day. Among the countless flowers of all possible hues, two in particular caught my eye: the water lily—the veritable emblem of this garden that has been immortalized on the canvases of the master—and the more discreet wisteria. A lover of Asian art as his print collection indicates, Monet constructed in his garden a Japanese footbridge paired with a pergola covered in white wisteria. This happy union reminds me of the Lion Grove Garden in Suzhou, in southern China, where a granite bridge with a wooden bower crosses a pond. White and mauve wisteria are intertwined on this structure like a fixed cascade. Numerous times have I painted these enchanted places where the pond water reflects waves of color.

"White and mauve wisteria are intertwined on this structure like a fixed cascade."

MONET not only conquered the prejudices of his contemporaries, but he also pushed his creation beyond known frontiers. The spirit of his Asian garden, with the asymmetry of its forms and the irregularity of its masses, blends harmoniously with the precise Western rigor of the planted flowers. This garden reflects the thinking of Monet, for whom flowers and trees were the sublime form of a Nature to which we also belong. To paint these elements is to let oneself be penetrated by Nature—not so as to become its interpreter, but rather to become a part of Nature itself. When we gaze on these works, we forget canvases and pigments. The painter's creation and Nature's work come together as one to form the beauty of a restored Unity.

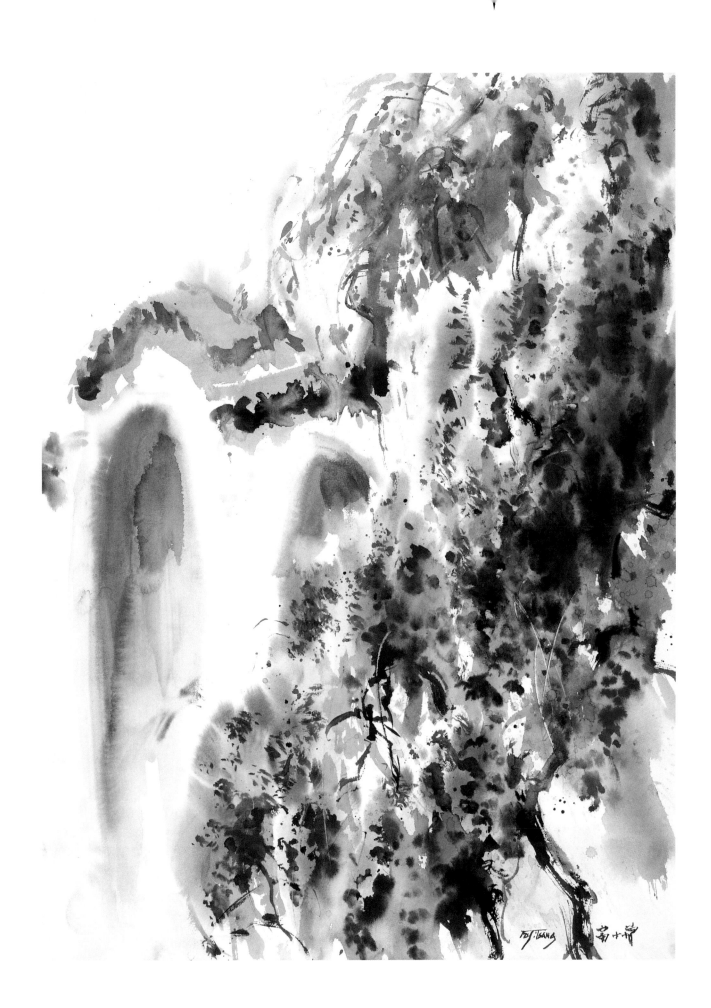

JASMINE

LETTER TO HIS BROTHER

I will see on our grenadiers
Their half-open red apples,
Where Heaven, as for its laurel trees,
Always preserves green leaves.
I will see this leafy jasmine tree
That shades the whole length
Of a rather spacious alleyway,
And the perfume of a flower
That in the frost still keeps
Its fragrance and its color.

THÉOPHILE DE VIAU

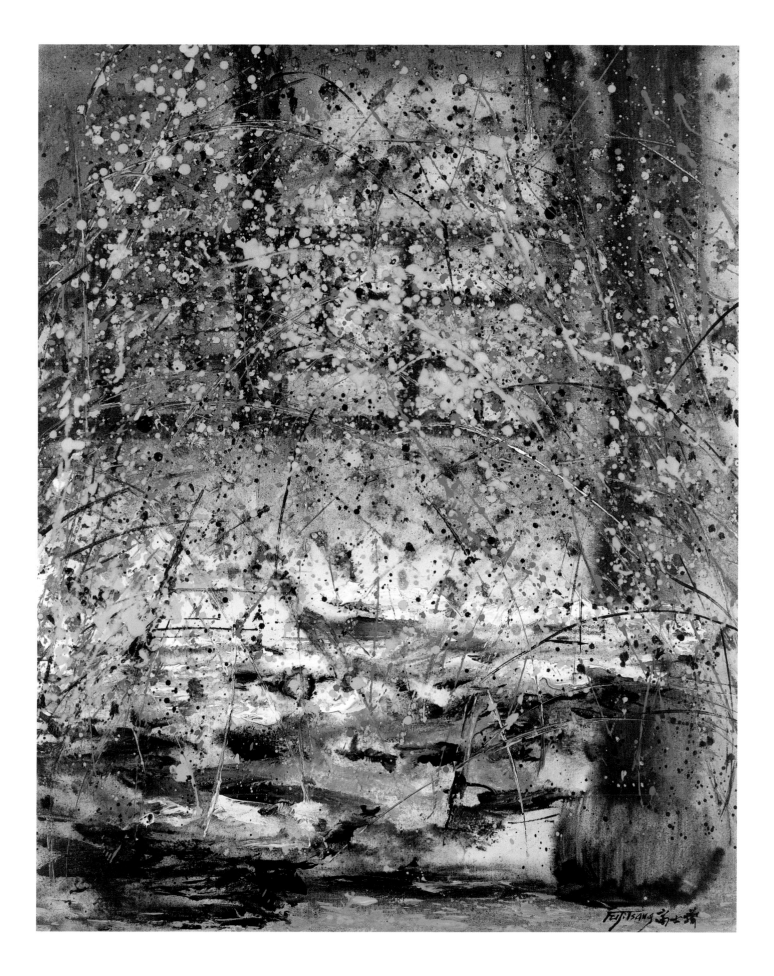

A FLOWER of my childhood, jasmine grew in the courtyard of our house with a jujube tree and a peach tree. Each summer, it gave off an overpowering fragrance. When night fell, the jasmine's heady perfume caused my father to sneeze on his way home. His sneezes indicated to me the arrival of a small gift—a half-melted stick of ice cream in the basket attached to his bicycle! This is perhaps why I love this flower.

"A flower of my childhood …"

JASMINE also has admirers in the West: the tiny flower has earned Chinese tea such a reputation that, for many Europeans, jasmine is synonymous with green tea.

Imported from Persia and the Middle East, jasmine has been cultivated in the southern French region of Grasse since the sixteenth century for the perfume industry. This is how a flower from the East made the fortune of the West!

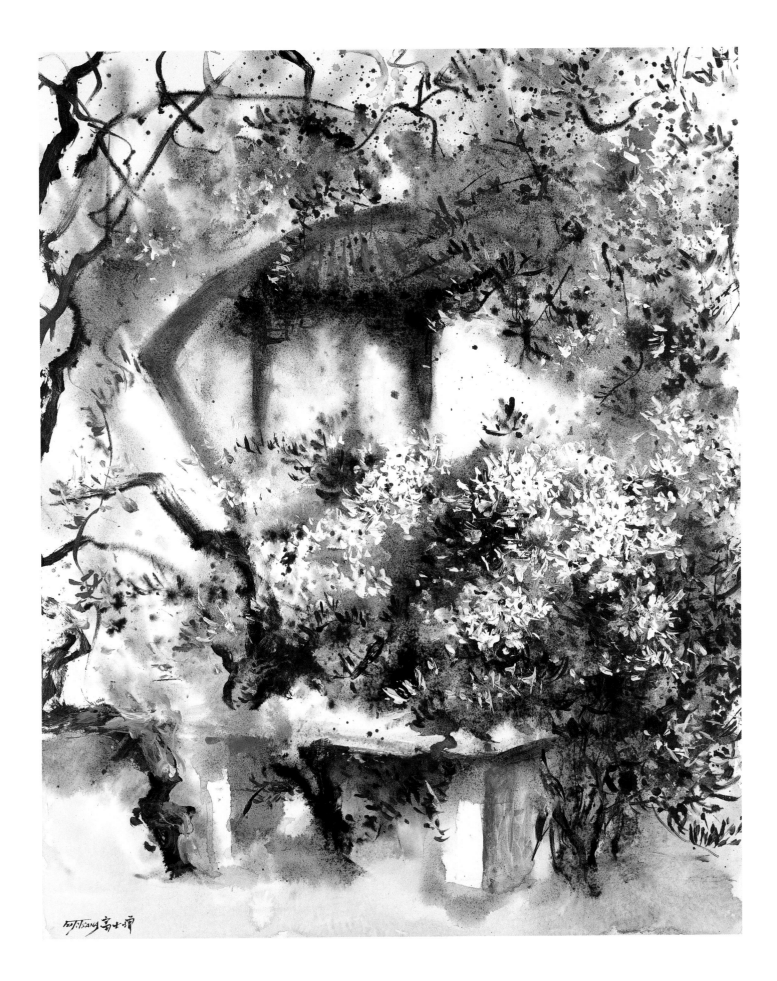

WILLOW

WILLOW WAVES

Row on row, unbroken, gossamer willows
Their images inverted into the clear ripples.
A study of those on the royal moat—yet not,
For there the spring winds bring the pain of parting.

Wang Wei
Translated from the Chinese by Peter Harris, *Zen Poems*,
edited by Peter Harris, Arthur A. Knopf, 1999.

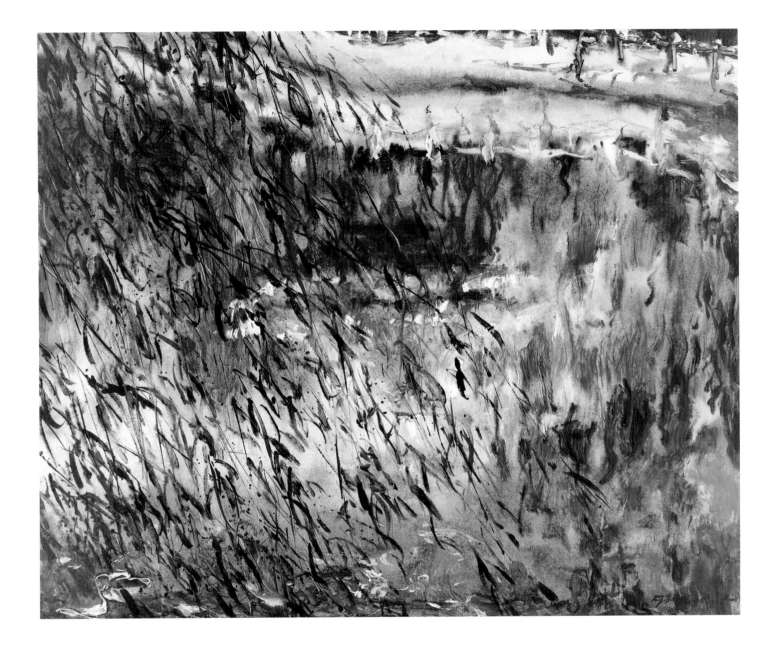

"… its leaves vibrate, agitated by a breeze, like a curtain of jade pearls."

AN INTIMATE ally of the Chinese landscape, the willow was already well known during the Song dynasty. Chinese poets compared the waves of its long catkins to the graceful movements of dancers, while painters saw in its leaves the delicately curved eyelashes of a beautiful woman.

I ASSOCIATE this tree with summer. Under a stifling heat, its branches bow towards the ground and its leaves vibrate, agitated by a breeze, like a curtain of jade pearls. Is it because its form suggests flowing tears that in the West it is named the "weeping willow?" Yet for me the willow is more rightly the symbol of a light and carefree existence.

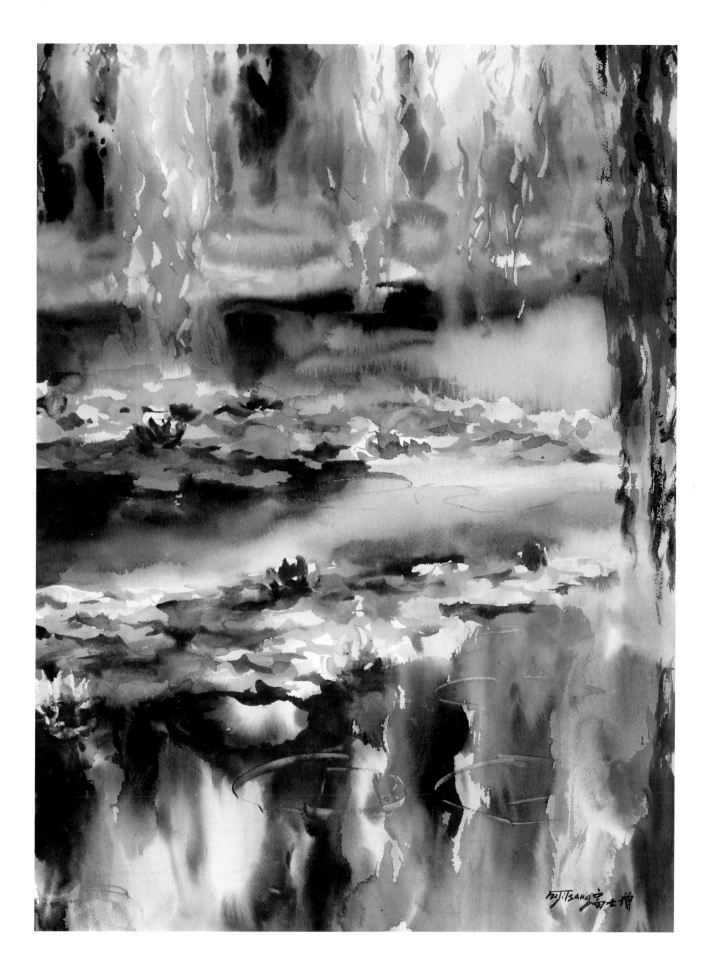

MAGNOLIA

LILY MAGNOLIA HOLLOW

On the tips of branches, hibiscus flowers
In the hills bear petals cased in red;
Down by the stream, by the deserted house
They bloom in profusion, then fall to earth.

WANG WEI
Translated from the Chinese by Peter Harris, *Zen Poems*,
edited by Peter Harris, Arthur A. Knopf, 1999.

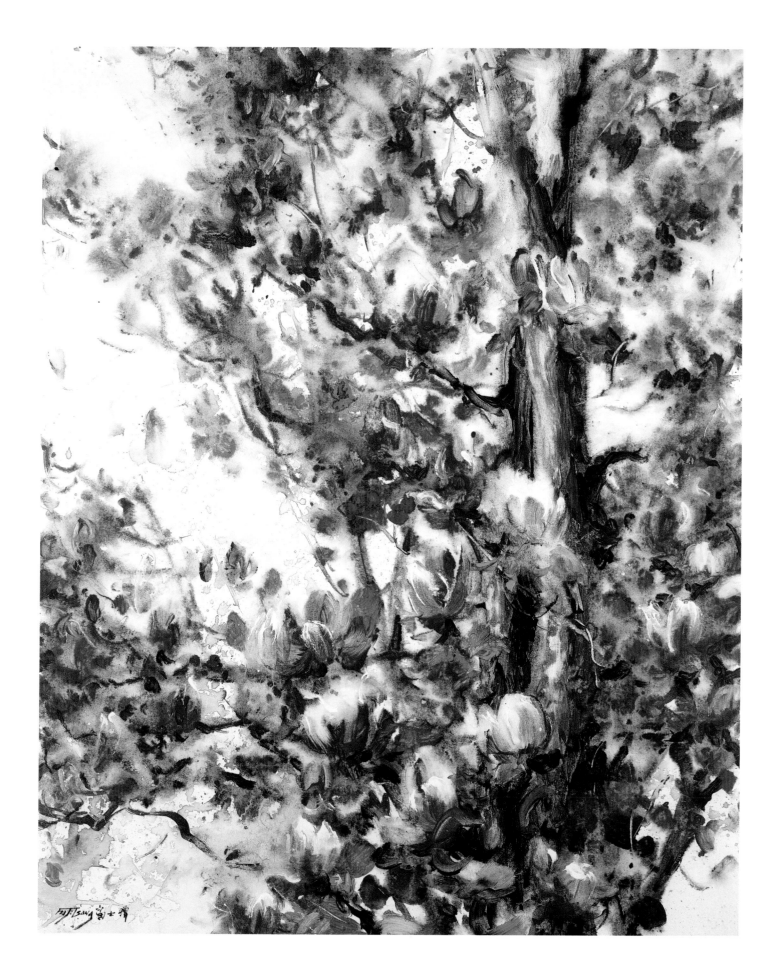

WATER LILY

TWO POEMS ON PAI-HUA ISLE

I. Wild banks, the stream curves a few times,
 The pine path passes through a blue shadow.
 I know not how far is the flowery islet,
 But I love the deep green on this water lily.

II. Water lily deep and luxuriant,
 Water is deep and wind is strong.
 Rain is over, a pure fragrance spreads.
 Sunset tips the city tower.
 Returning oar is followed by the shining moon.

OU YANGXIU
Translated from the Chinese by Amitendranath Tagore, *Moments of Rising Mist: A Collection of Sung Landscape Poetry*, Grossman Publishers, 1973.

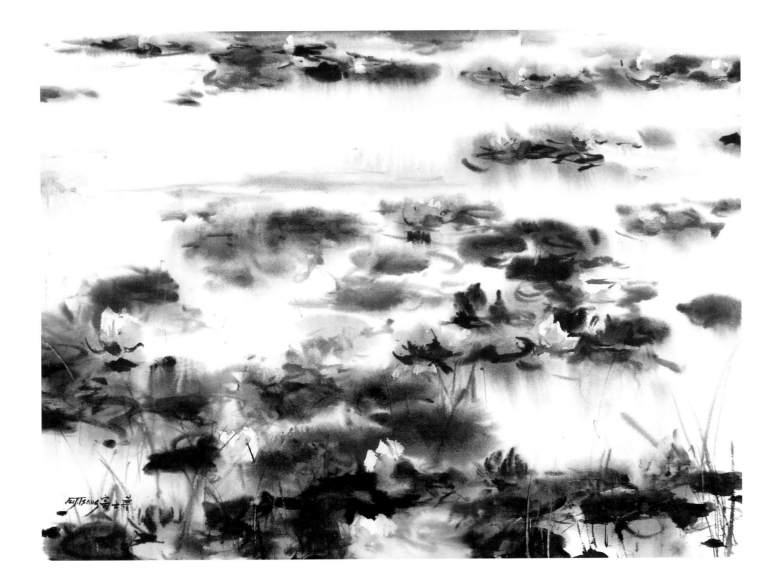

THIS LARGE AQUATIC FLOWER is known and appreciated the world over thanks to Monet. After producing a series depicting this flower and the Japanese footbridge in his garden, the artist decided to paint some very large formats focusing exclusively on water lilies in water. The resulting forty-eight paintings, exhibited at Durand-Ruel, created a true sensation. Georges Clemenceau, a friend of Monet's, offered the artist space in the Orangerie Museum in Paris to expose nineteen of the giant works.

"… water and flowers merge into one another."

THE MoMA in New York has dedicated an area to a series of paintings on the water-lily theme. During my numerous visits to the museum, I have sat in front of these huge canvases, allowing my gaze and my spirit to lose themselves in this calm, profound universe of Monet's who, by retaining only the water and flowers in the images, leads us straight to the essential: the space and its elements. The water lily's leaves and flowers are thus no longer interpreted as separate features, but become two components of creation in this space. The great brushstrokes that liberally cover the canvas do not serve to draw out each element, but rather to draw us into a universe where heaven and earth are one, where water and flowers merge into one another. These canvases do not describe the beauty of flowers, but Beauty in the sacred and universal sense of the term. One of the challenges in art lies in the uniqueness of creation. When a giant such as Monet opens up a new path, everything suddenly becomes obvious. But to take the path behind him is a perilous task …

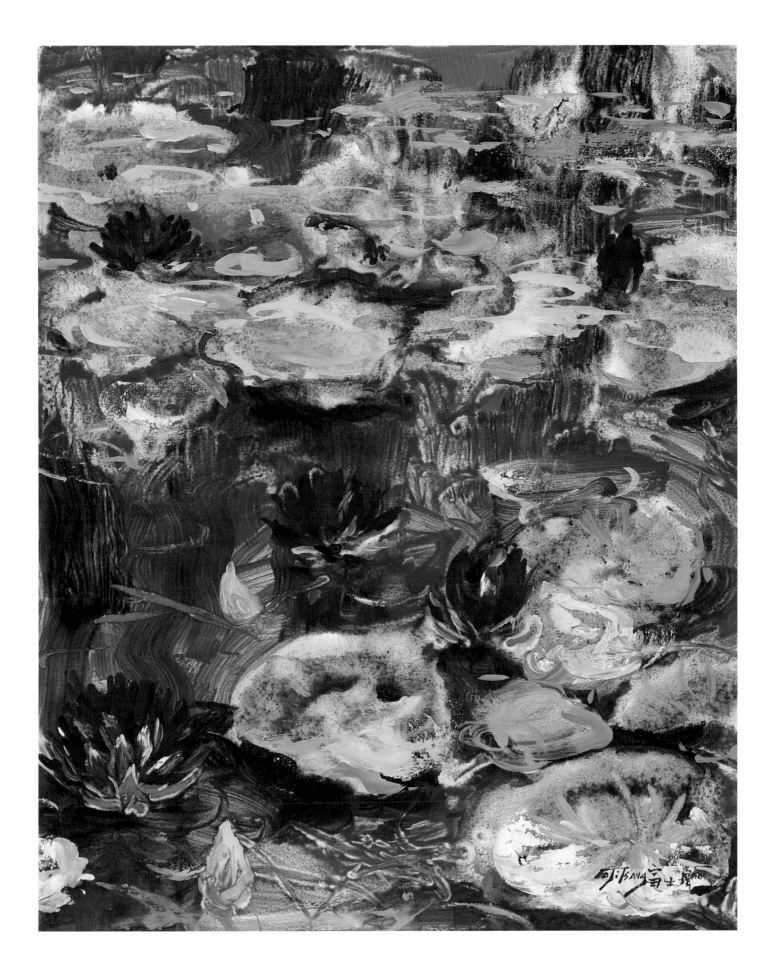

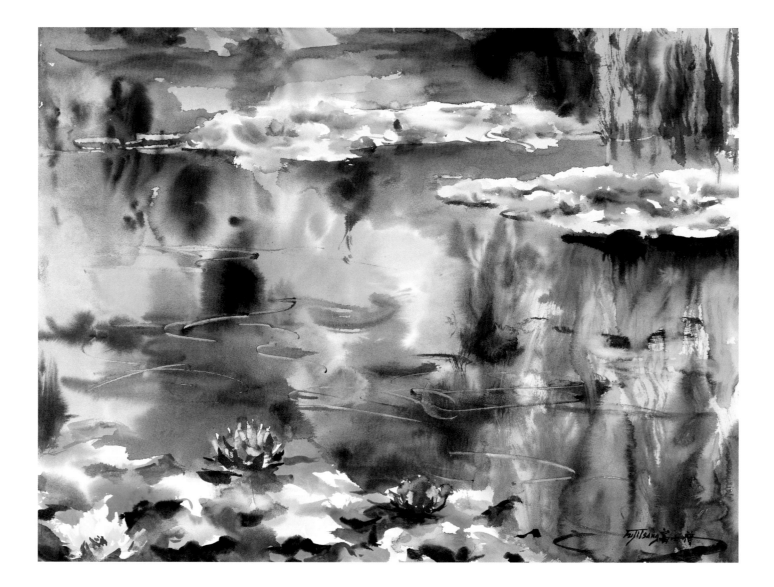

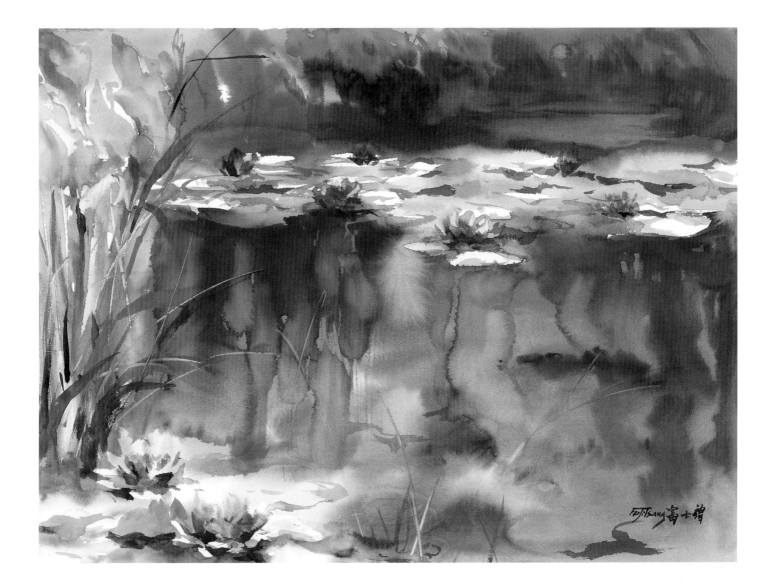

from THE PRINCESS

Now folds the lily all her sweetness up,
And slips into the bosom of the lake.
So fold thyself, my dearest, thou, and slip
Into my bosom and be lost in me.

ALFRED LORD TENNYSON

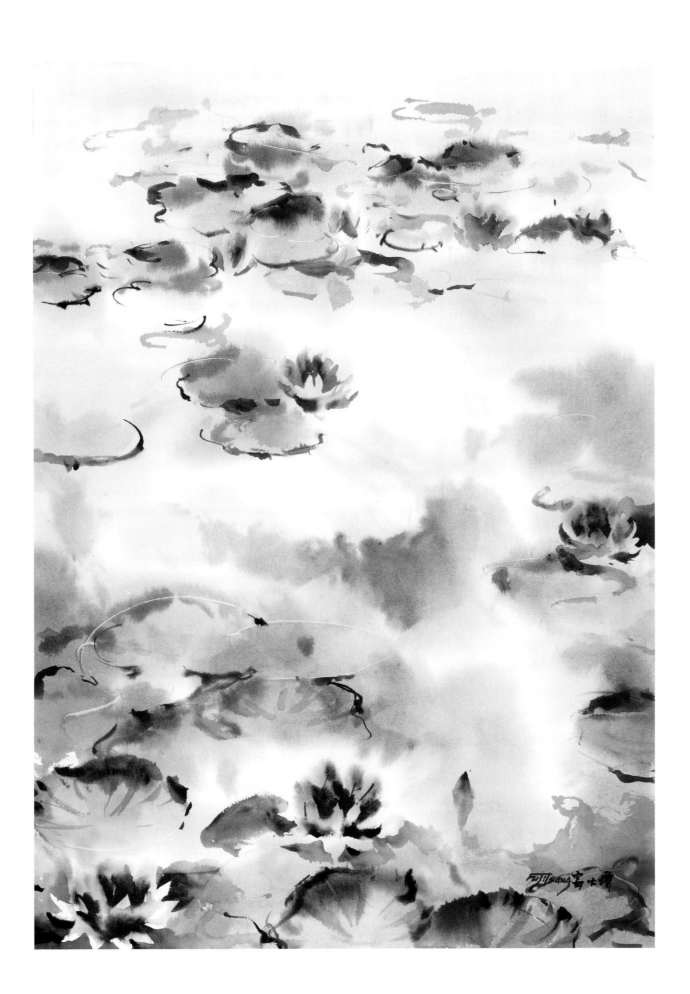

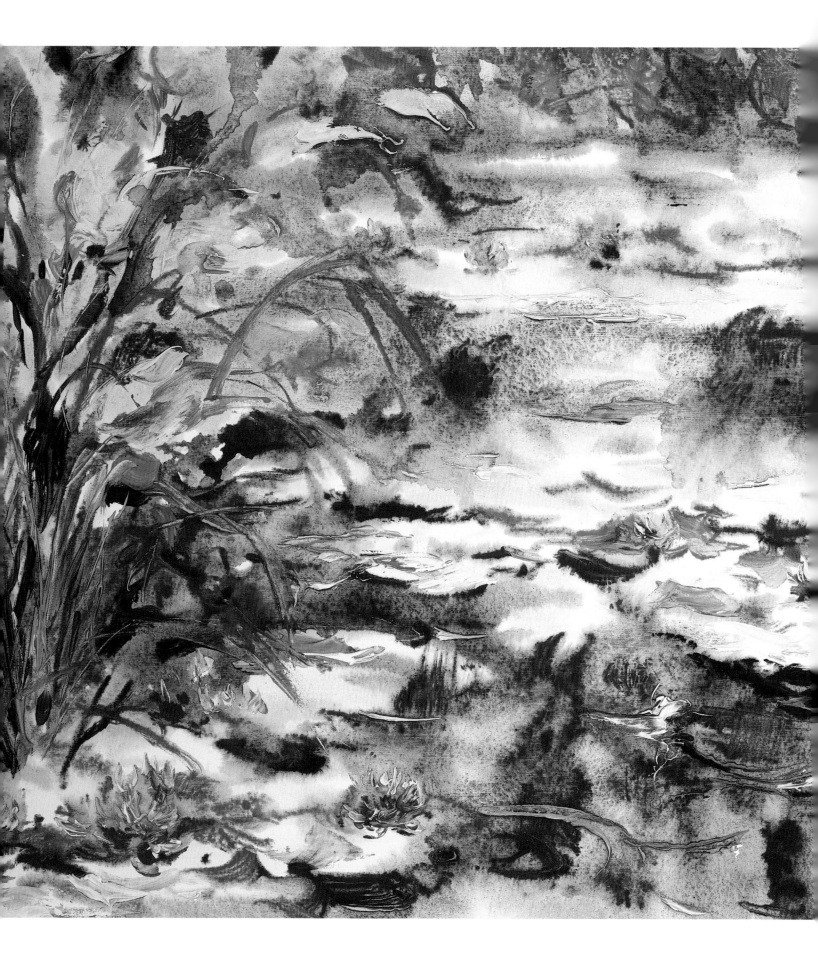

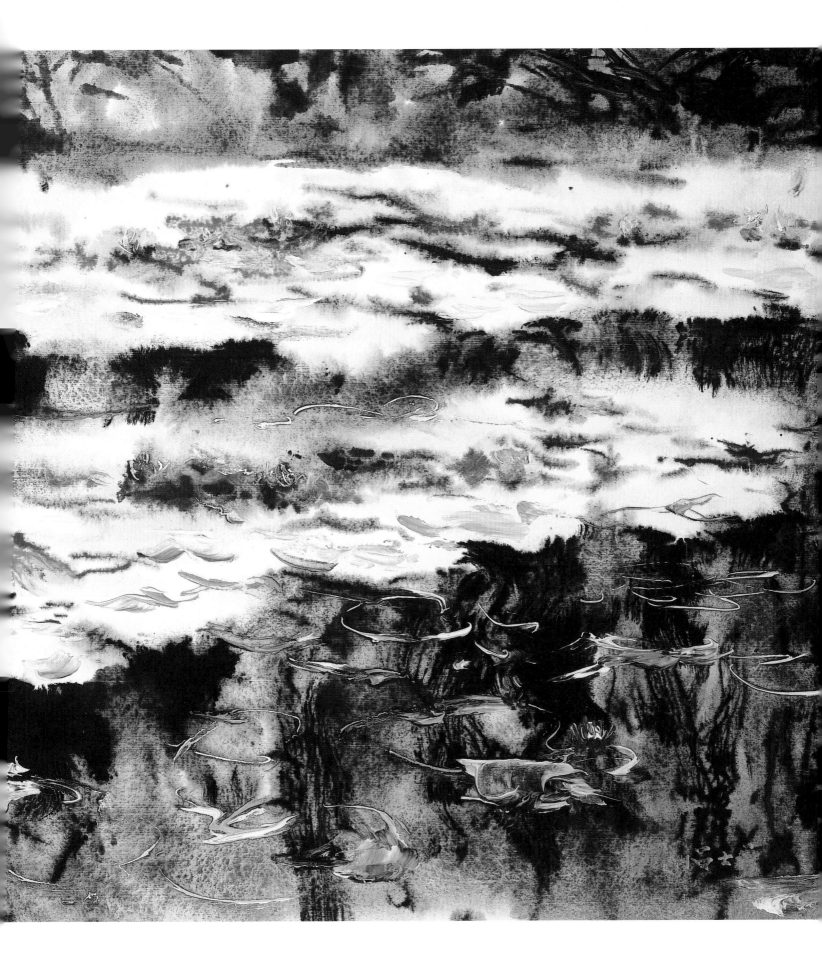

SUMMER

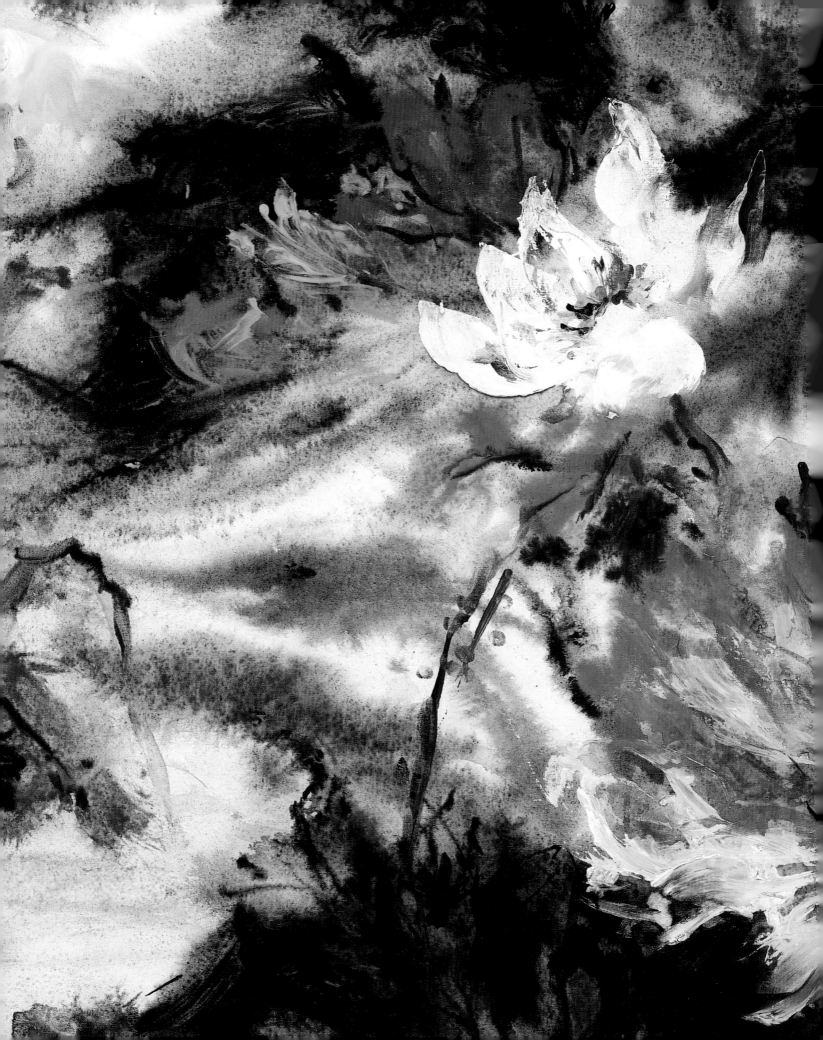

The rose laurels are in bloom and the pomegranate-picking season has started. These trees are your apple trees; the grasses in the fields are like aromatic herbs here. The forests are filled with pines, cypresses, oaks, green vines and plane trees… In short, this country is still as untouched and antique as its inhabitants, all fishermen, the landscape is unmatched in graceful beauty… This is Nature, pure and honest, as we love her… the sky is blue and warm, the blue is at home here.

Extract from a letter written by Félix Ziem to his friend Théodore Rousseau in 1860. Held at the Musée du Louvre, Departement des arts graphiques.

ROSE

O, how much more doth beauty beauteous seem
By that sweet ornament which truth doth give!
The rose looks fair, but fairer we it deem
For that sweet odor which doth in it live.

WILLIAM SHAKESPEARE, from Sonnet 54

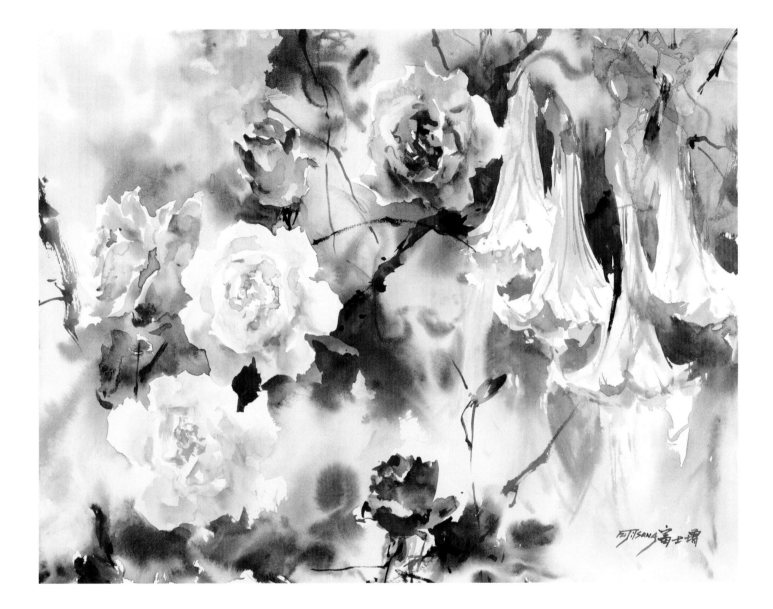

"… one captivates me in particular: yellow petals hemmed with fuchsia red."

THE ROSE conquered China to the point of rivaling the peony, national symbol of love and happiness. I painted my first roses in Nice, in the garden of the French Franciscan brothers of Cimiez Monastery. Climbing roses with heady perfumes form the multicolored bowers that contrast with the tones of the surrounding shade.

AMONG ALL THE MANY COLOR combinations of roses, one captivates me in particular: yellow petals hemmed with fuchsia red. This rose silently challenges me, for one would think the blending of these two almost complementary colors would be dull. However, using a technique of Chinese painting, with one color on the tip and the other on the body of the bristles, I recreate in a single movement the delicate transition of the flower's nuances. The result is full of spontaneity and freshness.

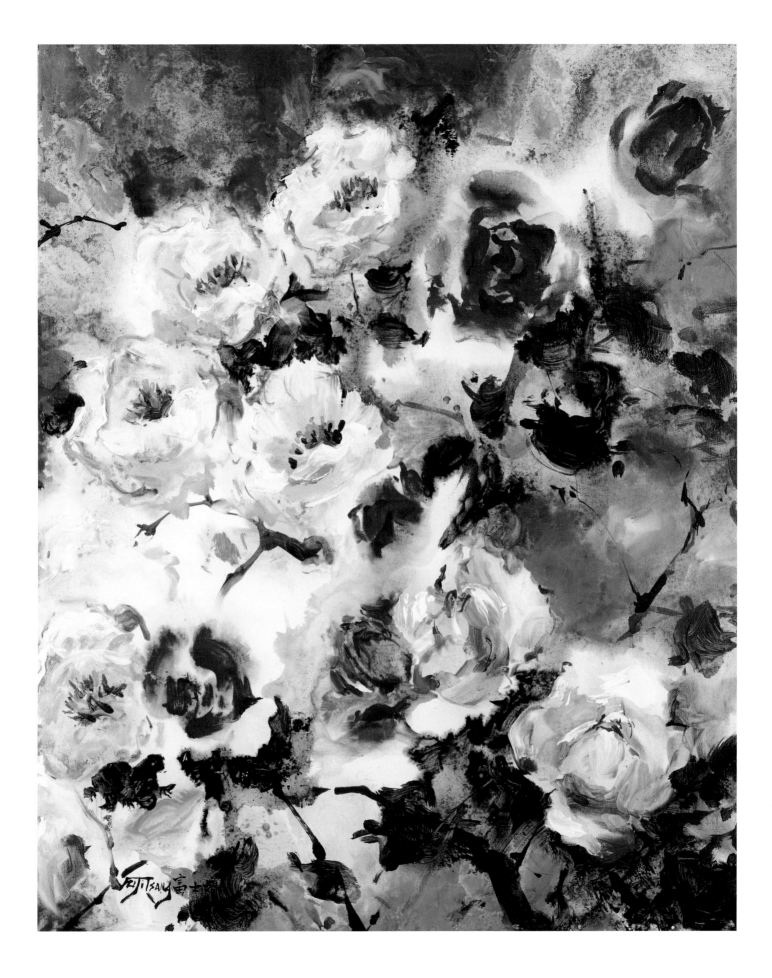

LOTUS

IN SUMMER AT THE SOUTH PAVILION THINKING OF XING

The mountain-light suddenly fails in the west,
In the east from the lake the slow moon rises.
I loosen my hair to enjoy the evening coolness
And open my window and lie down in peace.
The wind brings me odors of lotuses,
And bamboo-leaves drip with a music of dew....
I would take up my lute and I would play,
But, alas, who here would understand?
And so I think of you, old friend,
O troubler of my midnight dreams!

MENG HAOREN
Translated from the Chinese by Witter Bynner,
Jade Mountain, Alfred Knopf, 1919.

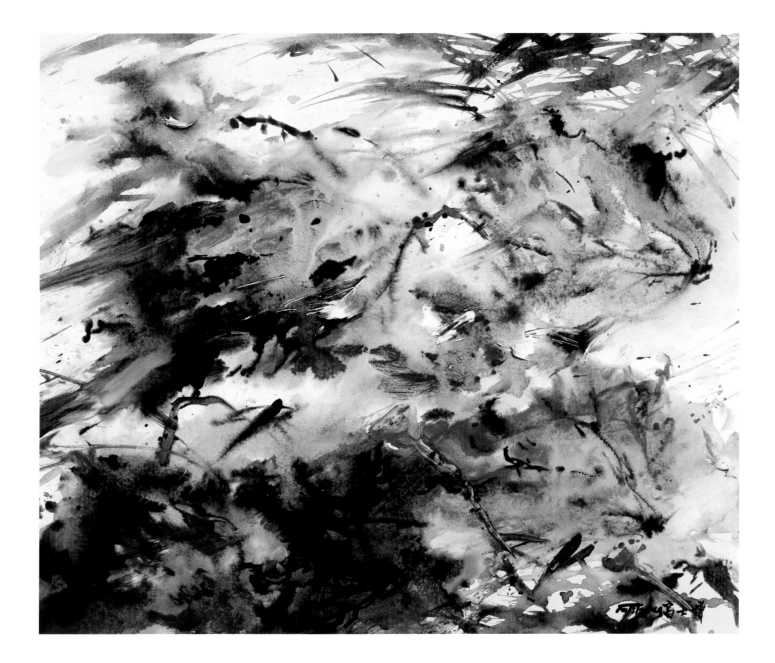

HIGHLY REGARDED by the Chinese, the lotus flower occupies an important place in their painting. For Buddhists, it symbolizes spiritual purity, for although it grows in mud, its flowers and leaves are unsoiled. This is why Buddha is often represented as being seated on a lotus flower. From generation to generation, the lotus has thus inspired painters with its beauty and call to spiritual elevation.

"When I think of the lotus, a marvelous memory comes to mind."

WHEN I THINK of the lotus, a marvelous memory comes to mind. During a trip to the lake at Yangcheng, next to Wuxi in southern China, I was lying in a little wooden boat as it slipped between large blue-green leaves and delicate flowers tinged from red to white. Intoxicated by their subtle perfume and dazzled by these flowers I had never seen so close up, I also discovered their petals covered with a fine down where water pearled in tiny droplets. The color of the leaves varies from season to season: from deep green when in water, to light blue when they emerge. Rolled up before unfolding gracefully, the leaves pass from green to gold. When the flowers fade and the petals fall, grain-filled cones appear.

A symbol of the different stages of existence, the lotus inspired me to create a series of paintings called "The Three Ages of Life."

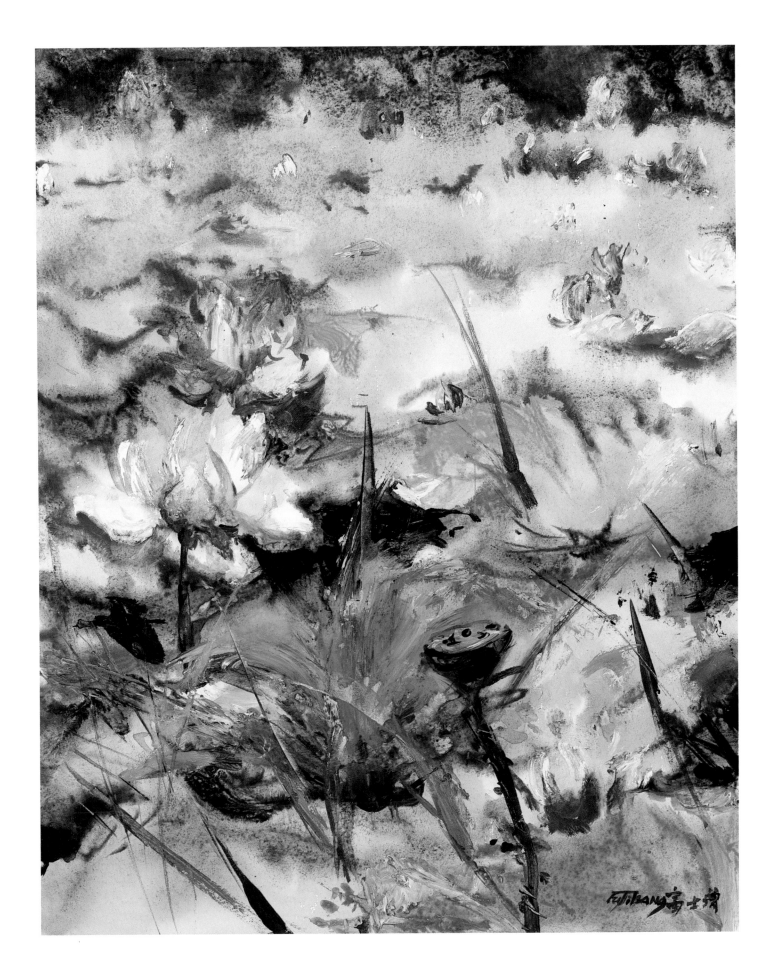

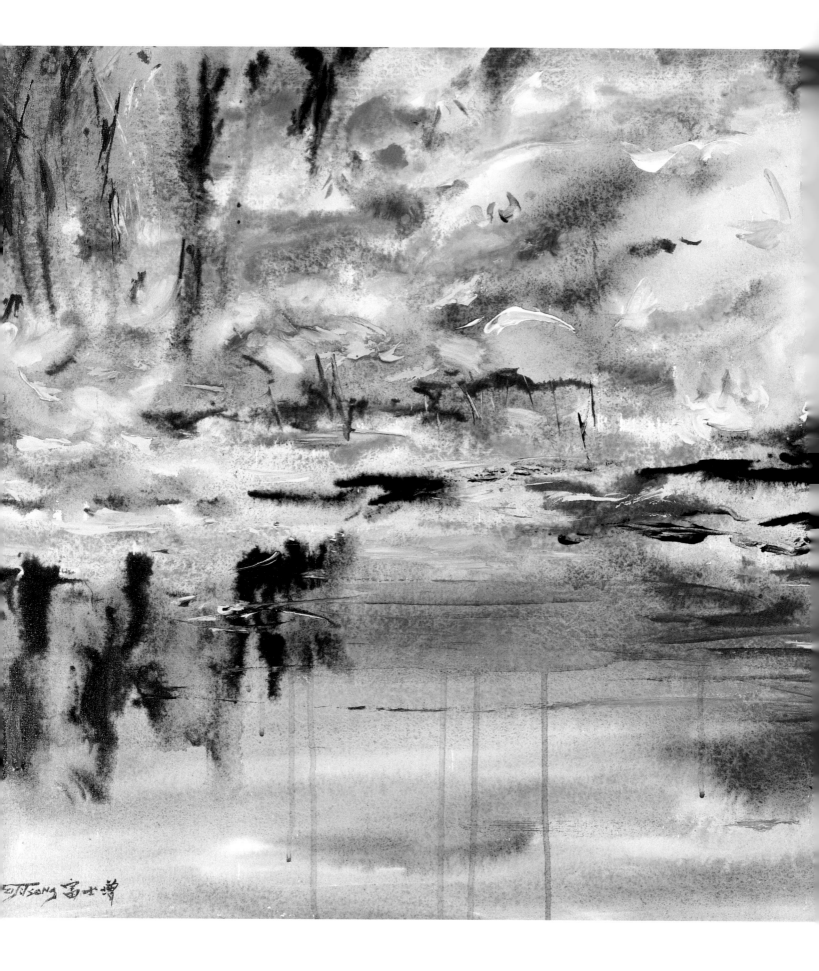

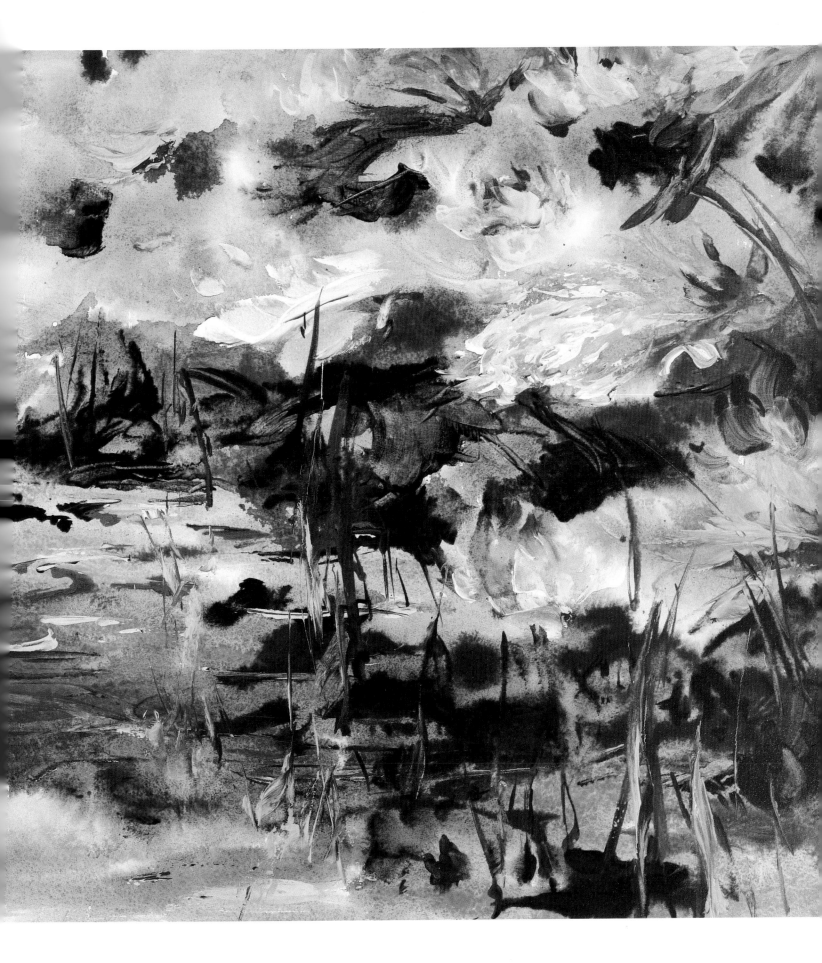

LAKESIDE PAVILION

A light boat greets the arriving guest,
Coming over the lake from far away,
Across the gallery we raise our cups;
On every side the lotus is in bloom.

Wang Wei
Translated from the Chinese by Peter Harris, *Zen Poems*,
edited by Peter Harris, Arthur A. Knopf, 1999.

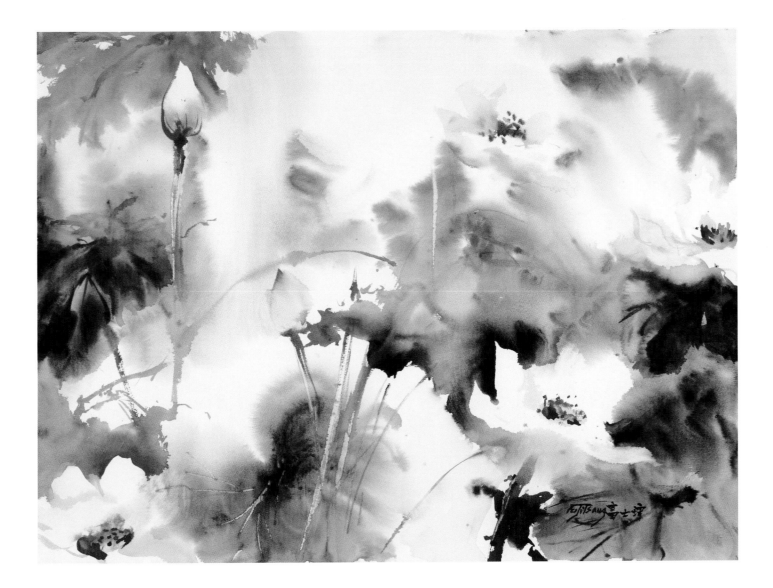

POPPY

from TAM O'SHANTER

But pleasures are like poppies spread,
You seize the flower, its bloom is shed;
Or like the snow falls in the river,
A moment's white—then melts forever.

ROBERT BURNS

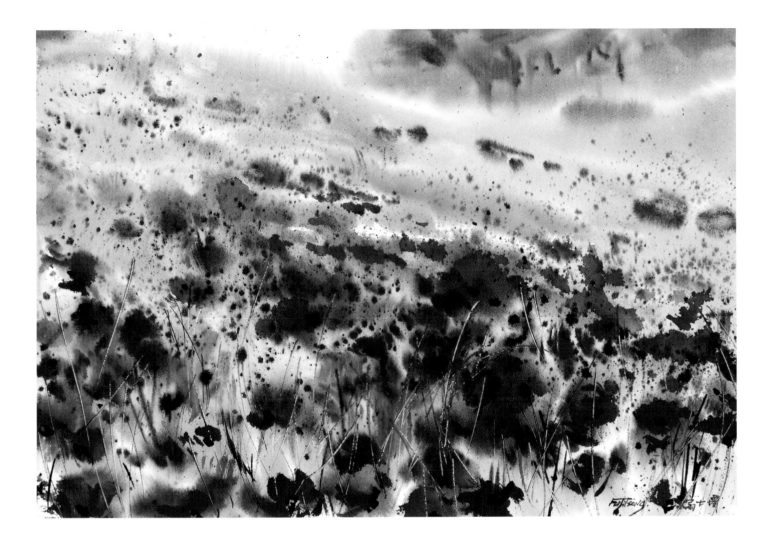

"… a pure and wild summer flower that refuses to be gathered."

I DISCOVERED the poppy in the works of Monet and Berthe Morisot. The latter, a friend of Manet's, often posed for the Impressionists. Who could fail to recognize the woman holding a parasol and strolling through a field of poppies represented by brilliant red blotches? This painting has intrigued me for years. Neither the human figure nor the poppies are detailed. Only touches of colors and streams of pigments appear. As if the sun had burned all the elements to leave only an impression of blinding light!

The poppy is a bit like this—a pure and wild summer flower that refuses to be gathered.

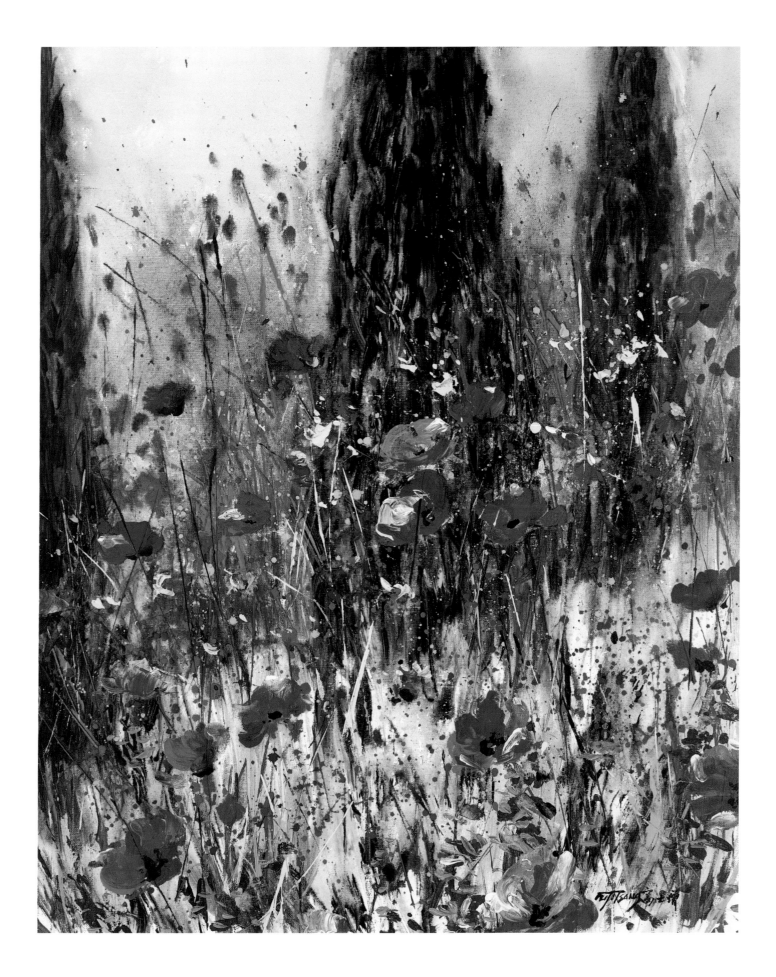

PLANE TREE

A VILLA AT LU-YUNG VILLAGE
ON AN AUTUMN DAY

Reject these worldly cares,
Walk leisurely with village idlers.
Sound of the trees; evening comes to the village inn.
Tinted grass, autumn comes to the old city.
Solitary bird streaks across the sky.
Lazy clouds pass over the dyke.
Don't ask who I am;
The hill, the trees, the empty boat.

XU XUAN
Translated from the Chinese by Amitendranath Tagore, *Moments of Rising Mist:*
A Collection of Sung Landscape Poetry, Grossman Publishers, 1973.

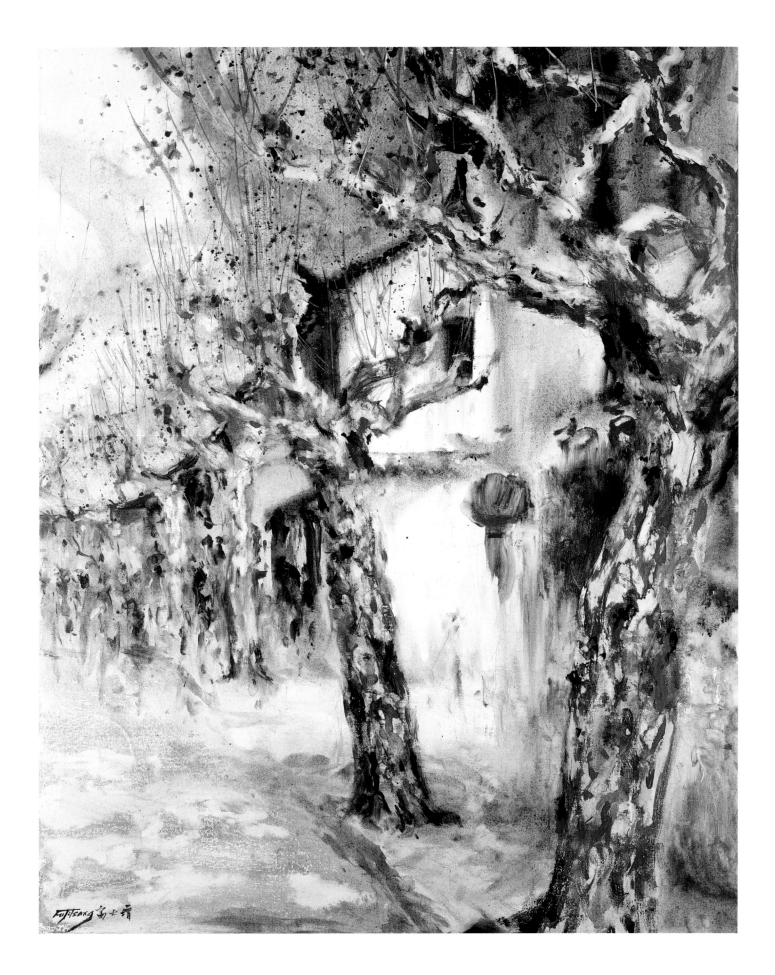

THE CHINESE word for a plane tree is pronounced *fa guo wu tong*, and in this ideogram *fa guo* means "French." So for the Chinese, the plane tree can only be French!

THE PLANE TREE is an essential part of the Provençal landscape, and the artists of the south of France have long painted it. Marius Roux-Renard, an early twentieth-century painter from Avignon, showed in his series of works the contrast between the deep green of the shade and the tender green of the Mediterranean light.

I LIKE THIS TREE. The varied blotches on its bark become even brighter and more colorful under the cobalt blue Mediterranean sky. In spring, its first light green leaves are gradually transformed into a dense green mass that covers the treetop in summer. My study of this tree over the years has puzzled me as the atmosphere can change very quickly.

"I like this tree."

THE PLANE TREE symbolizes summer. To understand and appreciate it better, one must have suffered the unrelenting Mediterranean heat where the air seems to stand still. The walls of houses are heated to the extent that the windows seem to shrink. People and animals desperately seek an elusive trace of shade. In the distance, on the surrounding hills drowned in a haze of heat, only the silhouettes of cypress trees are visible. On the village square, the plane tree offers a welcome and welcoming shade. Its greenery is refreshing. What a beautiful place Provence is.

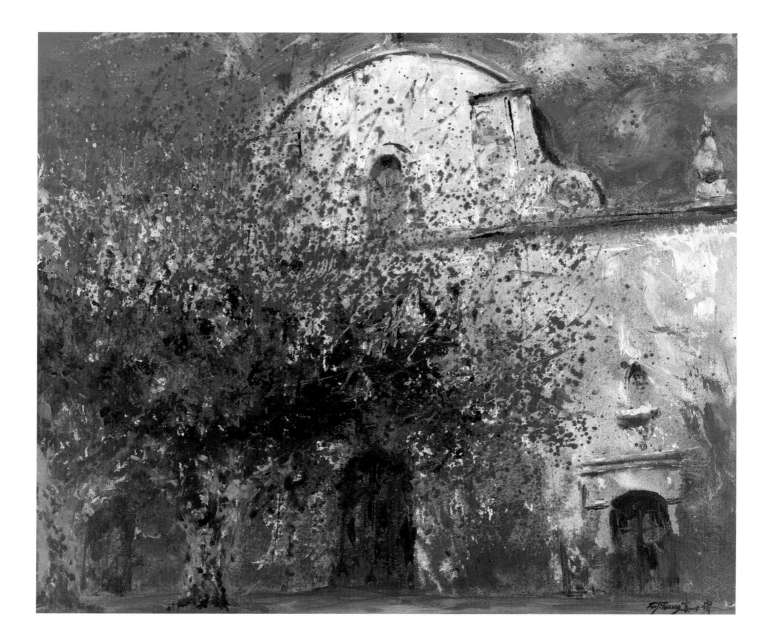

SUNFLOWER

We have here a glorious and intense windless heat—very much
to my liking. What more can one want than the sun, the light that
I cannot merely qualify as yellow, sulfur, pale lemon, gold.
How beautiful the yellow is! … I would like to decorate the studio.
Nothing but big sunflowers.

Extract from a letter written by VINCENT VAN GOGH to his brother Theo, 1888.

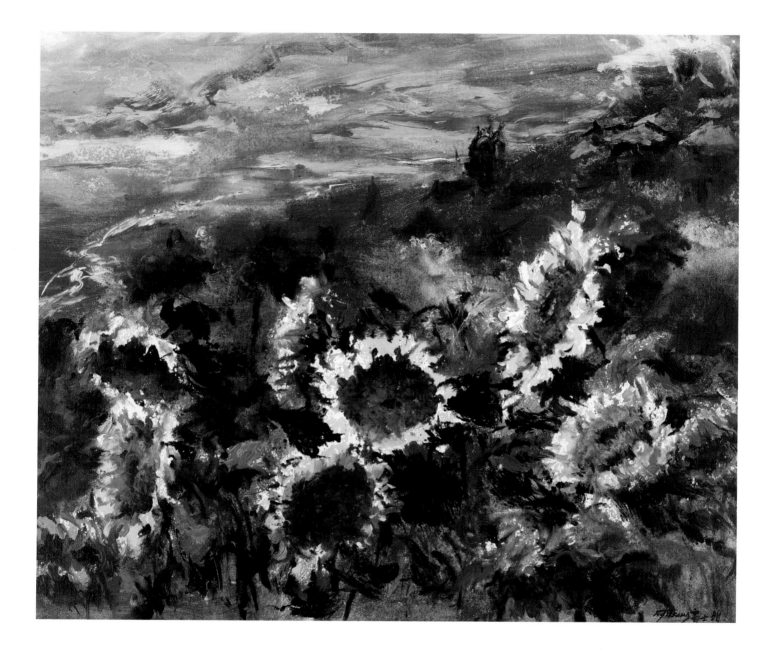

Is THERE a more appropriate symbol for the light of the south of France than the sunflower? "I have constant sun and I can erase and begin again as much as I like … After all this time spent observing outside, I've ended up no longer caring about the little details that darken the sun instead of bringing it out." Thus spoke Renoir from Cagnes-sur-Mer, where he had settled.

"It is not concrete matter that one attempts to portray, but the sun itself …"

In CHINA, when I was a sixteen-year-old sent to the countryside, I planted sunflower seeds. During this difficult adolescent period where life seemed to lose color and flavor, this flower attracted me by its unique quality of always turning towards the sun. To escape from the pain of reality, I took refuge in painting and passionately devoured books about the Impressionists and the masters of modern art. Despite the poor quality of the reproductions, their works allowed me to spend some unforgettable moments. With my eyes fixed on the pages, avid to discern each detail, I took to dreaming about these extraordinary beings and their creative freedom.

I BELIEVE that we cannot paint the sunflower like any other plant. It is not concrete matter that one attempts to portray, but the sun itself, the symbol of light. Its flamboyant yellow petals contrast with its heart in different nuances of black, brown and sepia. In life, light and darkness are inseparable, and the sunflower embodies these two extremes.

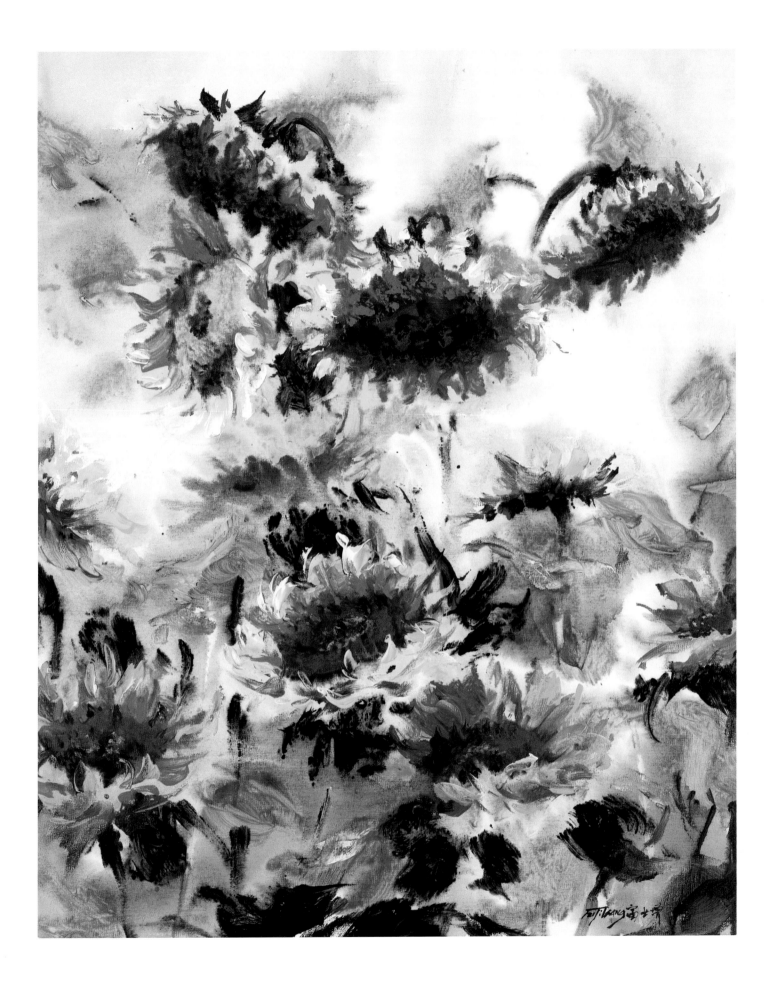

PINE

LIVING IN THE HILLS: IMPROMPTU VERSES

I close my brushwood door in solitude
And face the vast sky as late sunset falls.
The pine trees: cranes are nesting all around.
My wicker gate: a visitor seldom calls.
The tender bamboo's dusted with fresh powder.
Red lotuses strip off their former bloom.
Lamps shine out at the ford, and everywhere
The water-chestnut pickers wander home.

WANG WEI
Translated from the Chinese by Vikram Seth, *Zen Poems*,
edited by Peter Harris, Arthur A. Knopf, 1999.

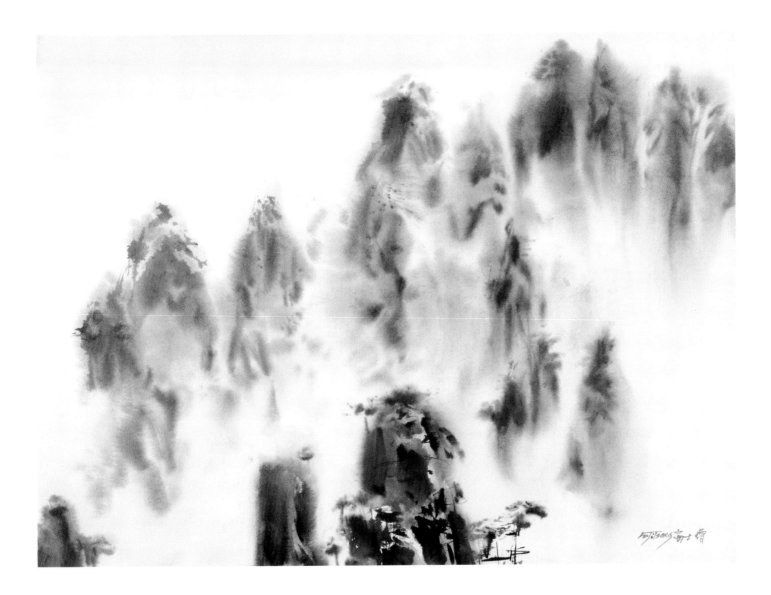

A RESIDENT of Nice by adoption, I find the light on the Côte d'Azur to be unique. Frank without being cruel, it brings out all sorts of contrasts through its transparency, while leaving an impression of weightlessness.

IN 1883, Nietzsche wrote the following to his sister: "The days here succeed one another with a beauty that I would describe as insolent. And what colors in Nice! It is a pity that I cannot detach and send them: they look as if they have been passed through a silver sieve, immaterial, spiritualized. They have skimmed off the brutality of rough tones. The charm of the coastal stretch from Alassio to Nice is due to the freedom with which a certain Africanism expresses itself liberally in the colors, the vegetation, the absolute dryness of the air. This is what makes this terrain unique in Europe."

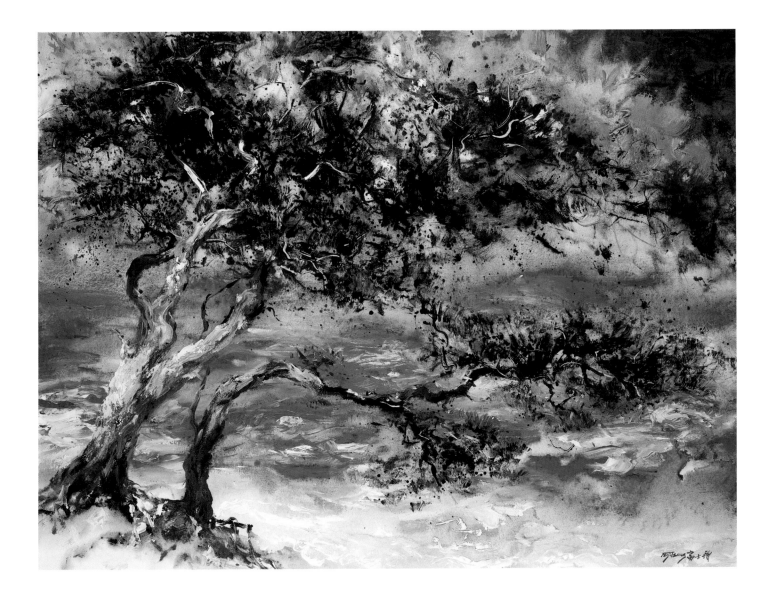

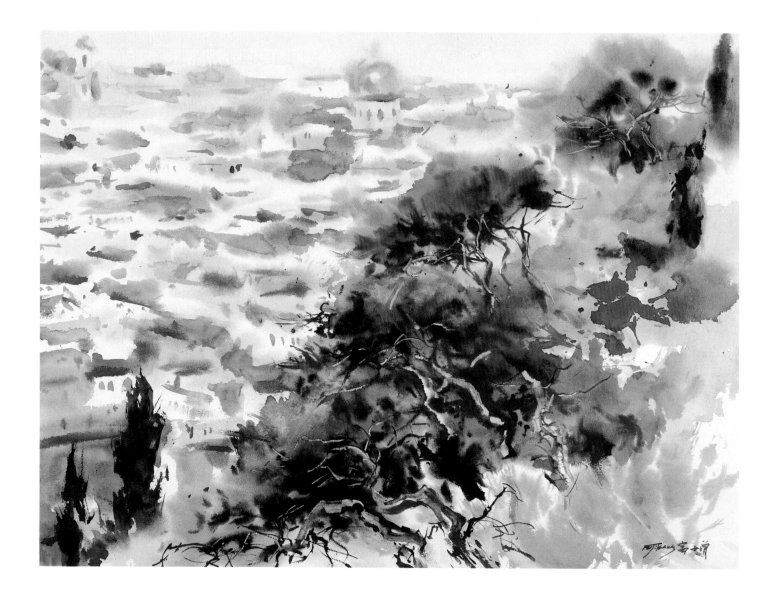

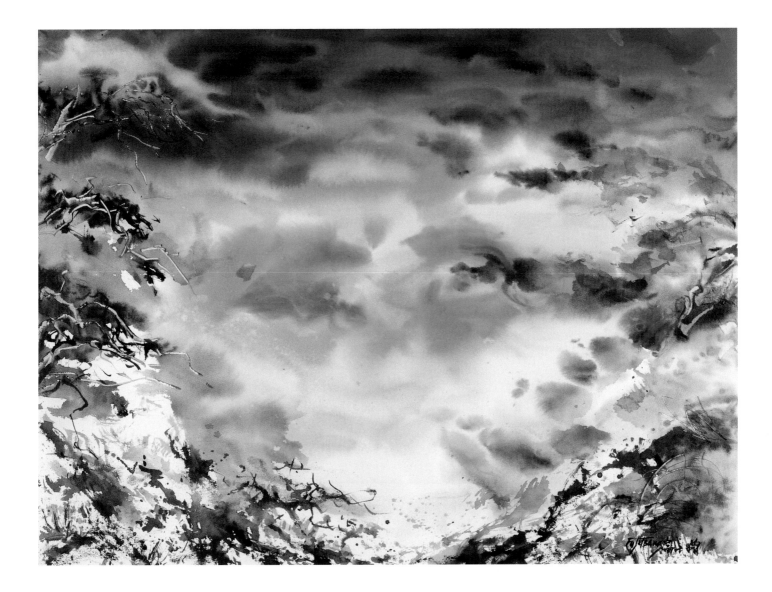

TRAINED TO USE Chinese ink in Beijing, my palette, somewhat drab when I arrived in France, gradually became more gay as I soaked myself in the light of Nice. At first, the bright colors of the works of Matisse and Raoul Dufy bewildered me until I saw these colors with my own eyes. The sea, its inlets, its peninsulas and its beaches are, in my eyes, the Mediterranean version of traditional Chinese "mountain and water" landscape painting. During my walks on these coastal trails, I have discovered the full palette of the Fauvist painters: the metallic and deep-sea blues of the watery depths; the cobalt blue of the azure sky; the turquoise of the waves and the mauve of the seaweed; the sienna or deep brown of the marine depths; the limpid green towards the beach; the creamy white of the sand bank; the yellow or bright ocher rocks. The trunks of the Aleppo pines, bathed in sunlight, partially masked by their branches with silky needles, cross the surface of the water in a graceful ballet and make this living tableau even more fantastical. The pines cling to the rocks: some, sculpted by the wind, stay close to the ground; others, very high, seem to touch the light.

"… some, sculpted by the wind, stay close to the ground; others, very high, seem to touch the light."

WHILE VERY SIMILAR in appearance to Mediterranean pines, Chinese mountain pines create an altogether different atmosphere. At the summit of the Huang Shan (Yellow Mountain), a source of inspiration for numerous artists, great centenarian pines, called "pines that welcome the visitors," stretch out their vigorous branches like so many benevolent arms. Other more knotty pines that grip the rocks resemble dragons displaying their claws. In winter, snow-laden pine tops emerge in the morning mist. The pines stand firm like valiant warriors that defend the mountain inhabited, so legend has it, by immortals. Not a single footprint on the immaculate paths.

All is silence and serenity …

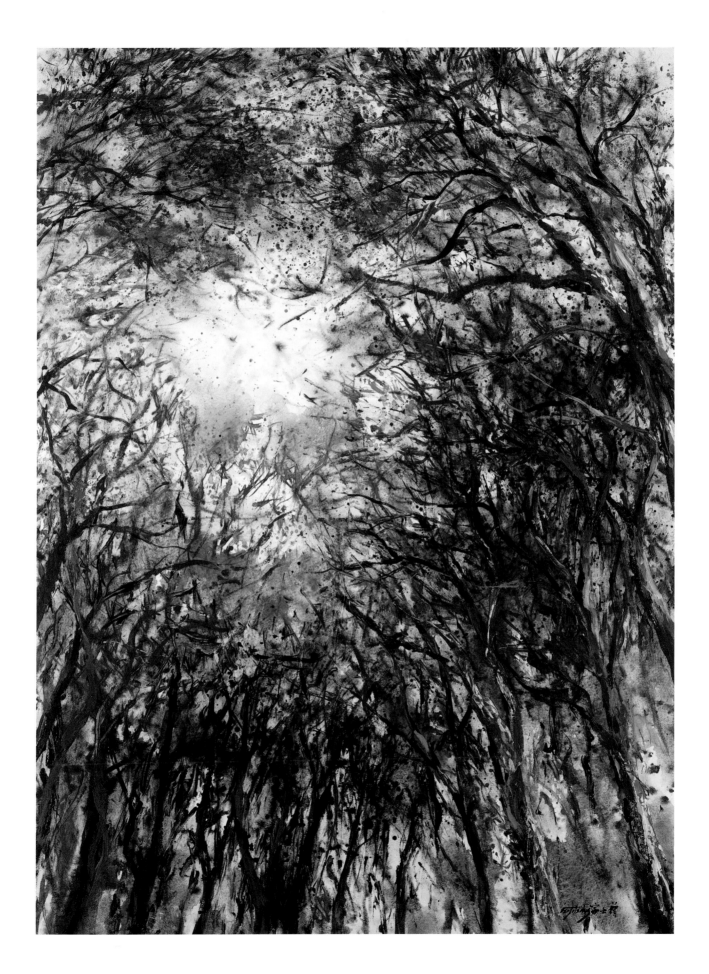

AUTUMN

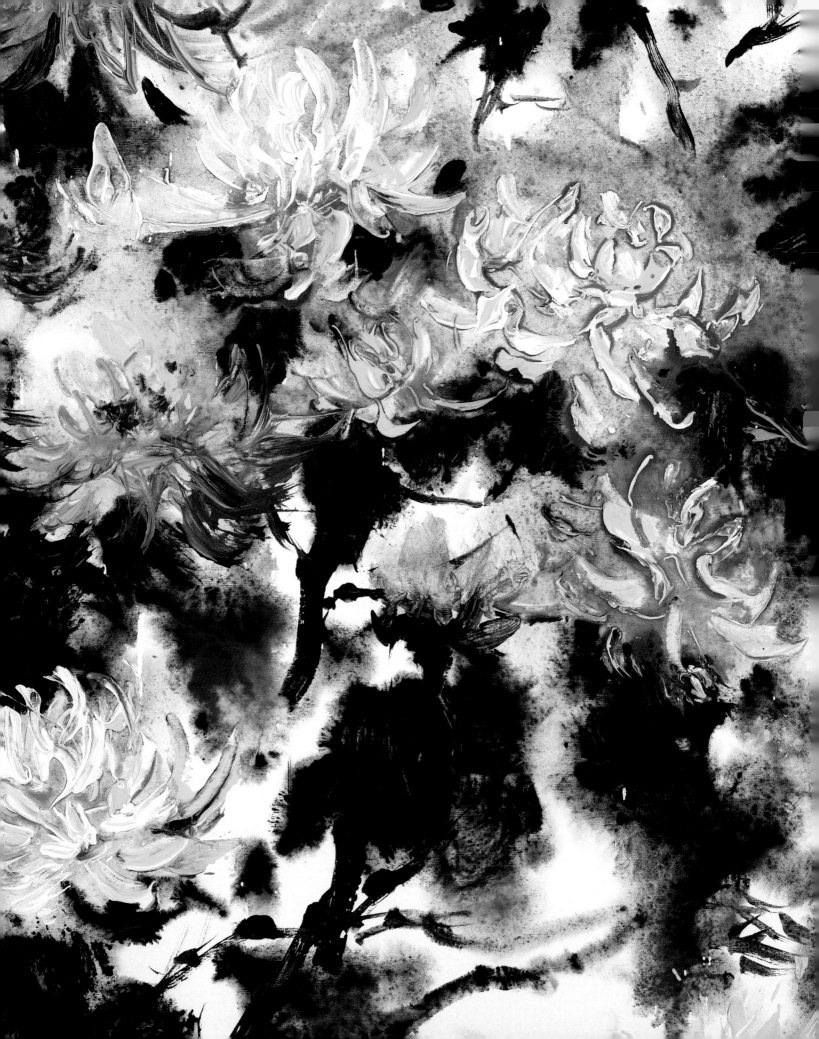

AN AUTUMN EVENING IN MY MOUNTAIN ABODE

Fresh rain has fallen on the vacant mountains;
Autumn's evening approaches.
The bright moon is shining through the pines,
The clear stream flowing over the stones.
Bamboos rustle, as washing maids return.
Lotuses stir: a fishing boat descends.
Let spring's fragrance vanish, as it will:
May the wanderer tarry, as he pleases.

WANG WEI
Translated from the Chinese by Bruce M. Wilson and Zhang Ting-Chen,
100 Tang Poems, Foreign Language Press, 1988.

OLIVE TREE

Peace can be read on a face that accepts that other things have received
their rightful meaning and place, and that these things form part of a whole
greater than themselves …

ANTOINE DE SAINT-EXUPÉRY, *Pilote de guerre*

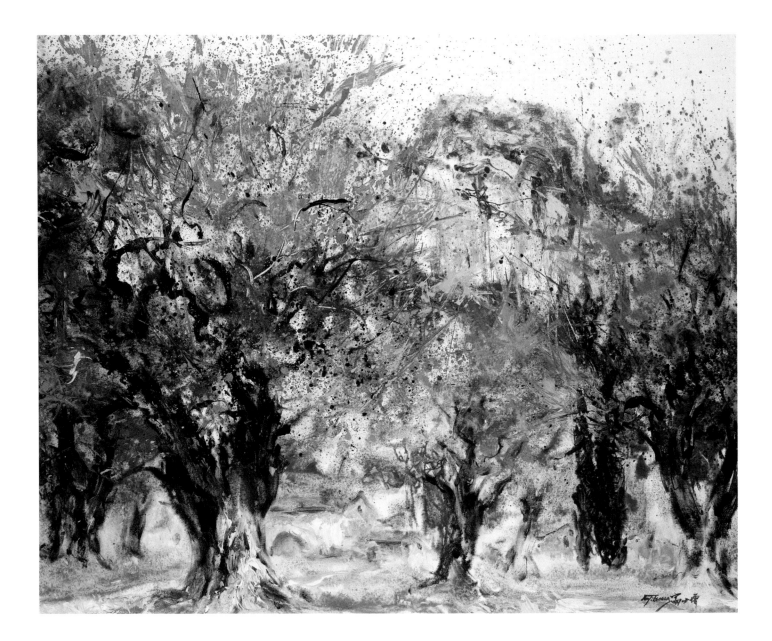

I DISCOVERED the olive tree when I arrived in Nice one October day in 1979. In the garden of the Ecole Nationale d'Art Décoratif where I pursued my studies, hundred-year-old olive trees with thick, tortured trunks and deeply scored, somber bark stretched out their roots. The colors of their leaves were striking. Gray-green on top, underneath they ranged from a silver tone to a violet blue, from golden yellow to almond green. The smooth young shoots, pale and straight, contrasted with the dark, tormented older branches. The trees' unique silhouettes impressed me as much as their subtle colors.

IN CHINA, when I was a child, I was struck by Picasso's "dove" carrying an olive branch in its beak. This brilliantly simple pencil work conveys such a clear symbol of peace that everyone recognizes it immediately, realizing its simultaneous fragility and resistance. Translating a symbol in an artistic work gives it force and clarity and facilitates its understanding and diffusion.

"The trees' unique silhouettes impressed me as much as their subtle colors."

OF COURSE, the olive tree does not have the cedar's majesty nor the birch tree's elegance. However, on this often dry and arid Mediterranean land, which trees can live several hundreds of years? When I paint these massive trunks—sometimes emptied of their insides—I imagine the rigorous tests they have endured. A magnificent symbol of life in the face of death, the olive tree incarnates the ancient tradition of this Mediterranean with which I fell in love. Love and passion: these two words sum up the link uniting the Mediterranean people to the olive tree.

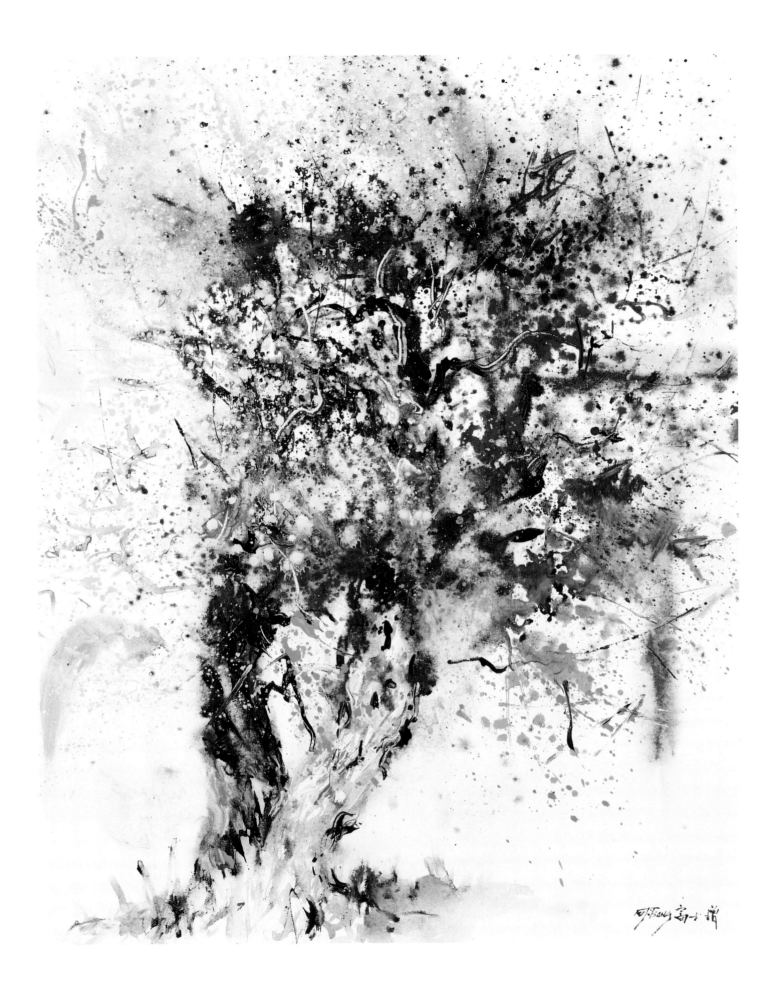

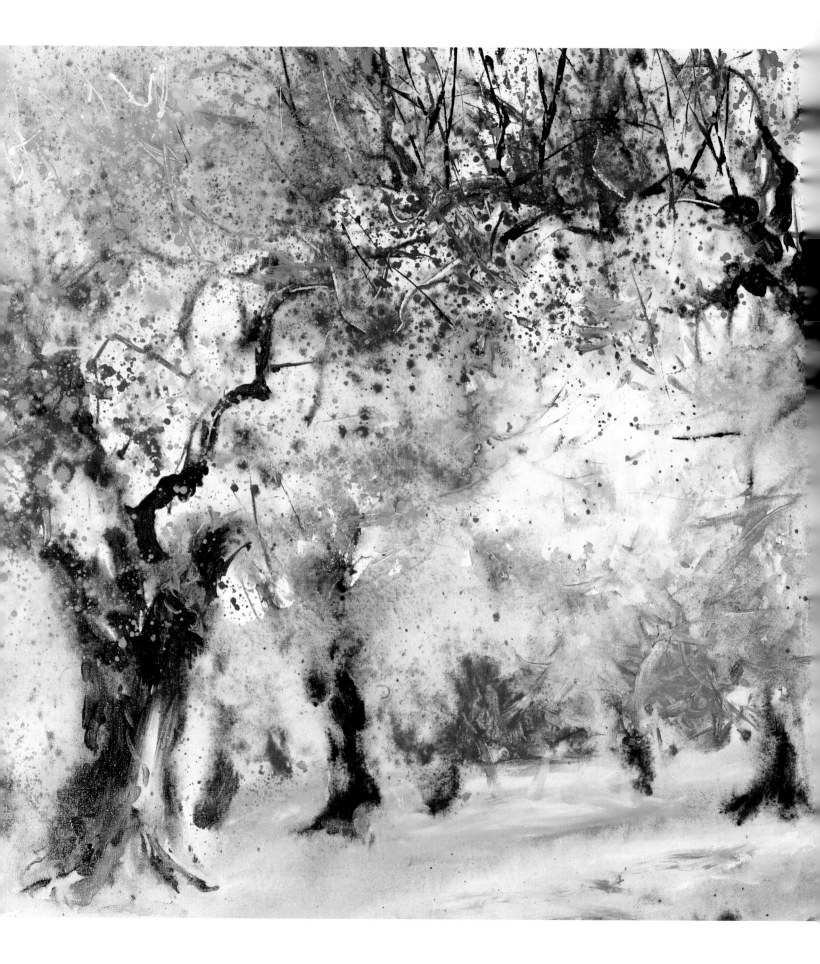

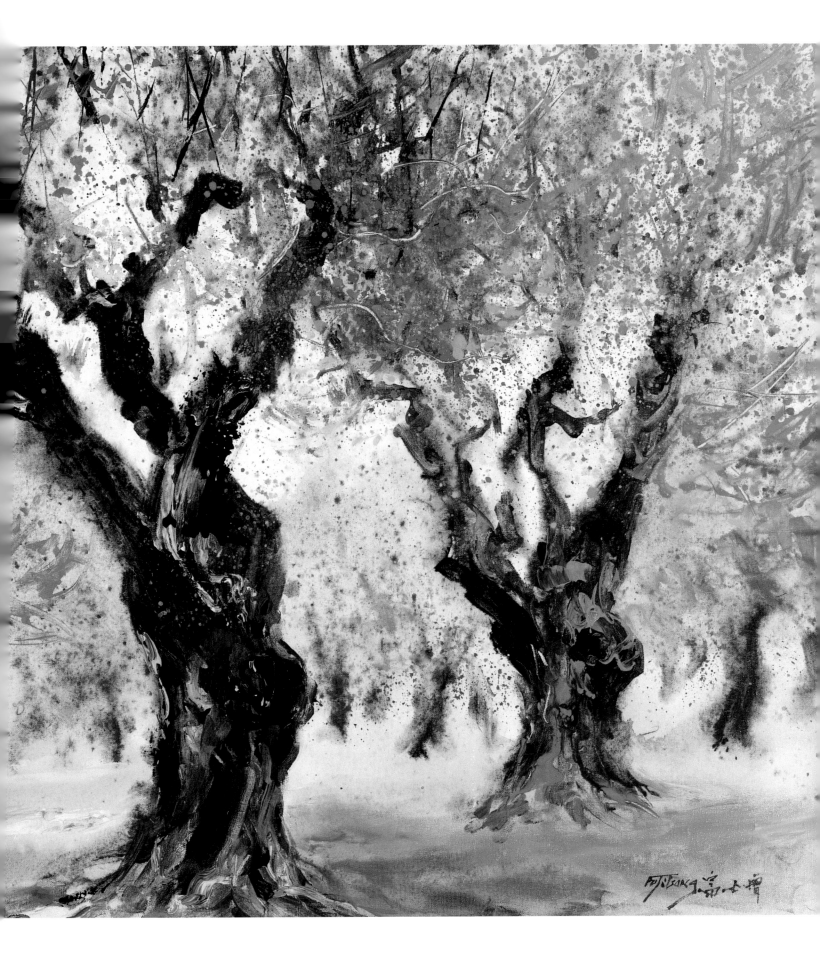

CHRYSANTHEMUM

RISING EARLY

Chrysanthemums in bloom—as gaunt as ever;
Peonies, leaves falling off, seem completely withered.
A locust, frozen nearly to death,
Clings desperately to a cold branch.

YANG WANLI
Translated from the Chinese by Jonathan Chaves, *Zen Poems*,
edited by Peter Harris, Arthur A. Knopf, 1999.

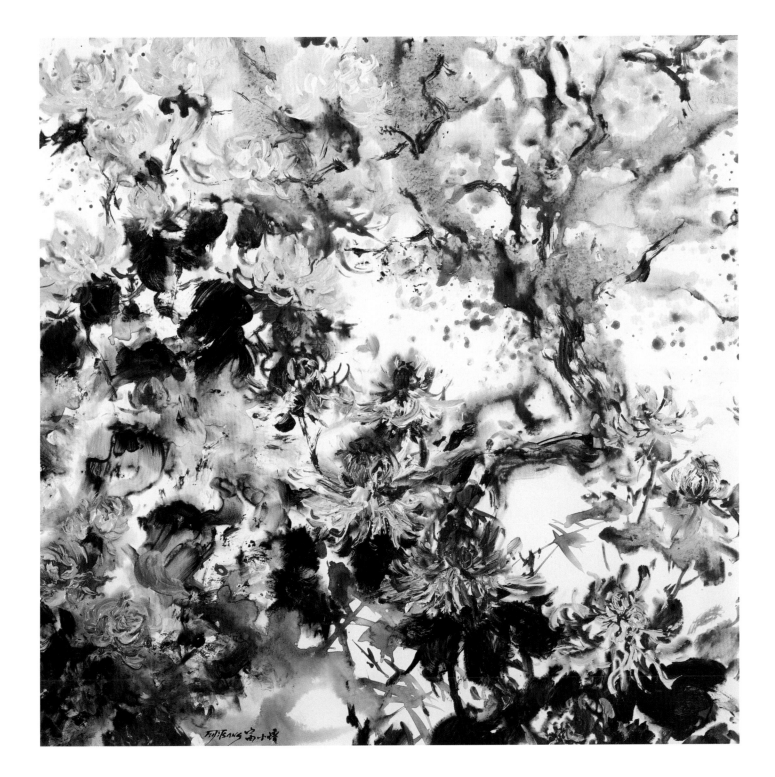

IN CHINA, autumn is synonymous with the Chrysanthemum Festival. In the parks of southern China, hundreds of trees form complex arrangements that sometimes draw more than a million visitors. According to the legend of Shen Nong, god of the peasants, in the district of Nanyang there is a lake surrounded by wild chrysanthemums, whose water is capable of lengthening the lives of drinkers to more than a hundred years. Ever since, chrysanthemums have been cultivated close to wells or lakes. Tao Yuan-Ming wrote one of the first poems on this flower. For this great man of letters from the Eastern Jing dynasty, the chrysanthemum symbolized the "virtue of the gentleman who cultivates himself early to bloom late." Like the autumn when it appears, the chrysanthemum is associated with ripe age. In China, Confucianism teaches the respect of tradition and of ancestors who stand for experience and wisdom. The older one gets, the more respectable one becomes. First loved and venerated by the Chinese, the chrysanthemum was taken to Europe in the eighteenth century by the Dutch, then spread to all the continents. In France, this flower is associated with All Souls' Day, when it is laid on tombs to commemorate the dead.

In China, more than three thousand varieties exist, with different forms and colors. The petals can be single- or double-layered, curly or straight, similar to needles that resemble a dragon's claws or in the form of a snowball. Lovers of this flower name it more poetically the "drunken goddess," the "dance of the phoenix," "ten thousand scarlet sunsets" …

"… the 'dance of the phoenix,' 'ten thousand scarlet sunsets' …"

FEW CHRYSANTHEMUMS are found in the south of France, but I have had occasion to study them carefully in the course of my trips to China. I also sift through my memories and imagine them according to the atmosphere I want to create. I like to paint these flowers by alternating transparent layers of glazing and a thicker texture as a relief. To balance their volume and contrast, I keep white spaces on the canvas. I thus combine Western technique with the principle of "full and empty," so dear to the Chinese tradition. Matisse also kept large blank surfaces in his works, making his poetic, evocative compositions sober yet vibrant.

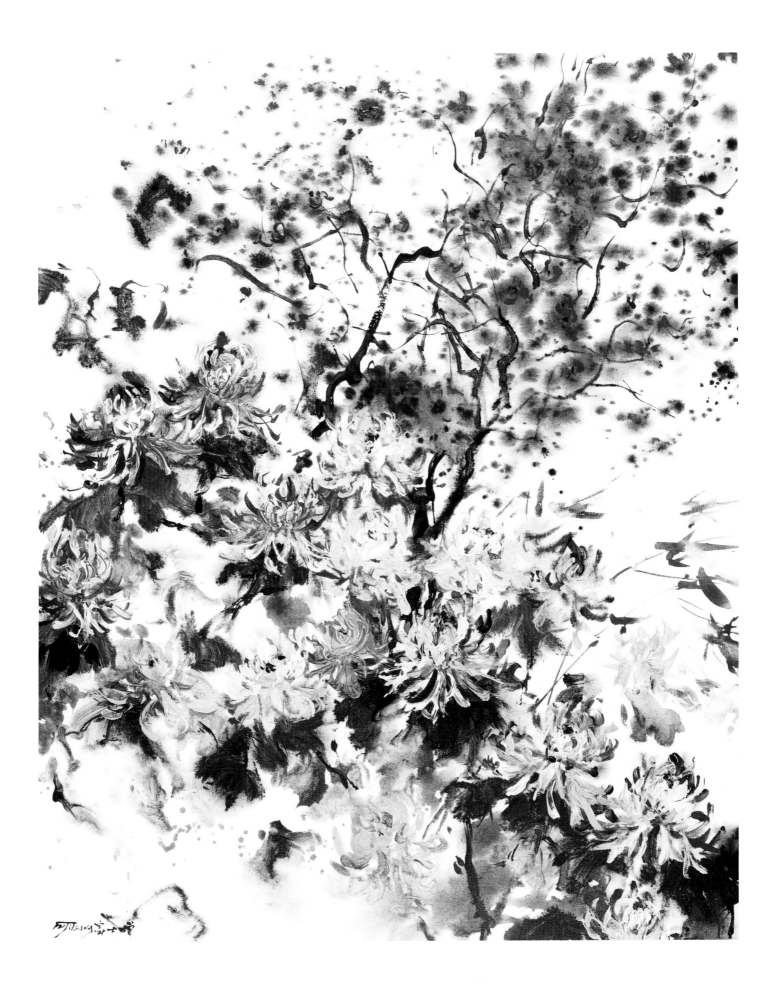

BIRCH

from BIRCHES

I'd like to go by climbing a birch tree,
And climb black branches up a snow-white trunk
Toward heaven, till the tree could bear no more,
But dipped its top and set me down again.
That would be good both going and coming back.
One could do worse than be a swinger of birches.

ROBERT FROST
The Poetry of Robert Frost: The Collected Poems, Complete and Unabridged, edited by Edward
Connery Lathem, Henry Holt and Company, 1979.

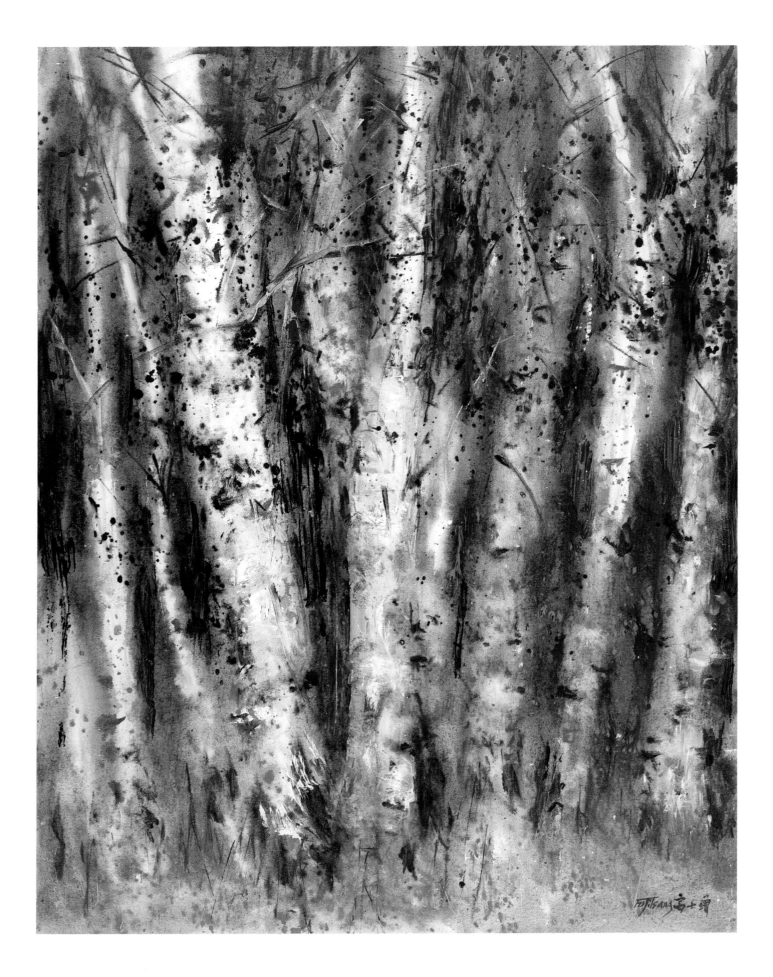

ALTHOUGH THE BIRCH TREE proliferates in northern China thanks to its capacity to grow in difficult conditions, I had never noticed it until I studied a series of paintings by the Impressionist painter Alfred Sisley. Contrary to the common belief that objects have an intrinsic color that they keep permanently, the light and the reflection of surrounding hues can in fact radically modify our perception of the form and color of objects. The birch tree is light-colored, but Sisley depicted it with daring colors, such as blue and violet on the trunk in a snowy landscape, or red and gold on autumn branches.

"… thanks to this tree I discovered the relationship between light and color …"

INSPIRED BY THIS DISCOVERY, I seized my palette and sketchbook. I mounted my bicycle and headed straight for the Imperial Canal in Beijing to study the birch in real life, like Sisley. What a surprise! The colors were really there! I simply had not known how to perceive them. I enthusiastically embarked on a series of studies of the birch in different weather conditions in the four seasons. It is thanks to this tree, dressed in such a pale-colored tunic, that I discovered the relationship between light and color, and I remain indebted to it.

ELUSIVE because of its bodiless transparency, light needs a support to become visible. I believe that color is the concrete manifestation of light in the same way that the symbol is a messenger of the sacred. This notion is found in both Eastern and Western philosophy. By fine-tuning our spirit and our gaze, we can perceive the sacred through the symbols of trees and flowers. To deprive the natural elements of this metaphoric dimension and to reduce them to a superficial beauty would amount to ignoring that color and light are one and the same.

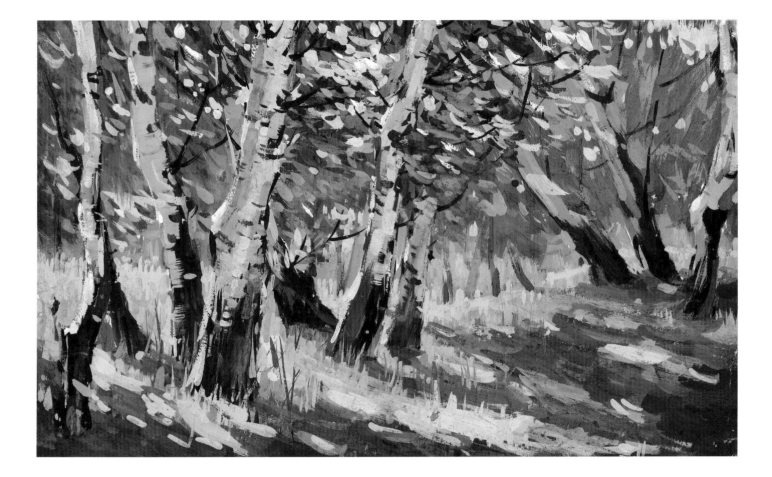

CEDAR

FOR HIS COUSIN

See the gaunt mountain-pine
Above the wind-swept vale!
Wild as the gale may whine,
Its bough no moment quail.
When frost and ice lie drear,
They stand the whole year long:
They feel not coldness near,
The pine and cedar strong.

LIU CHEN
Translated from the Chinese by John A. Turner, *A Golden Treasury of Chinese Poetry*,
edited by John J. Deeney, Renditions, 1976.

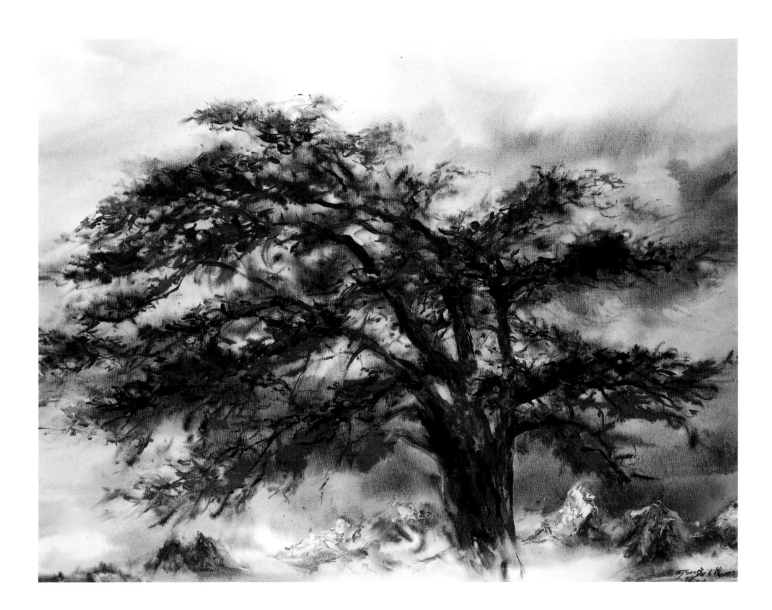

THE CEDAR, this great majestic conifer, stretches its powerful arms out to the world. With its layers of foliage and its flattened top, it signals its presence from afar, and its somber silhouette overshadows all other trees.

ON THE HEIGHTS where vegetation is sparse, the cedar is all the more beautiful, standing on the slopes like a lonely giant. When I place my hand on its deeply notched trunk covered in moss, I am filled with a heady sensation of power. Its impressive branches spread in all directions. Its dense leaves allow a subdued light to filter through. Its trunk seems to touch the sky … Venerated by our ancestors, this tree also inspires deep respect in me.

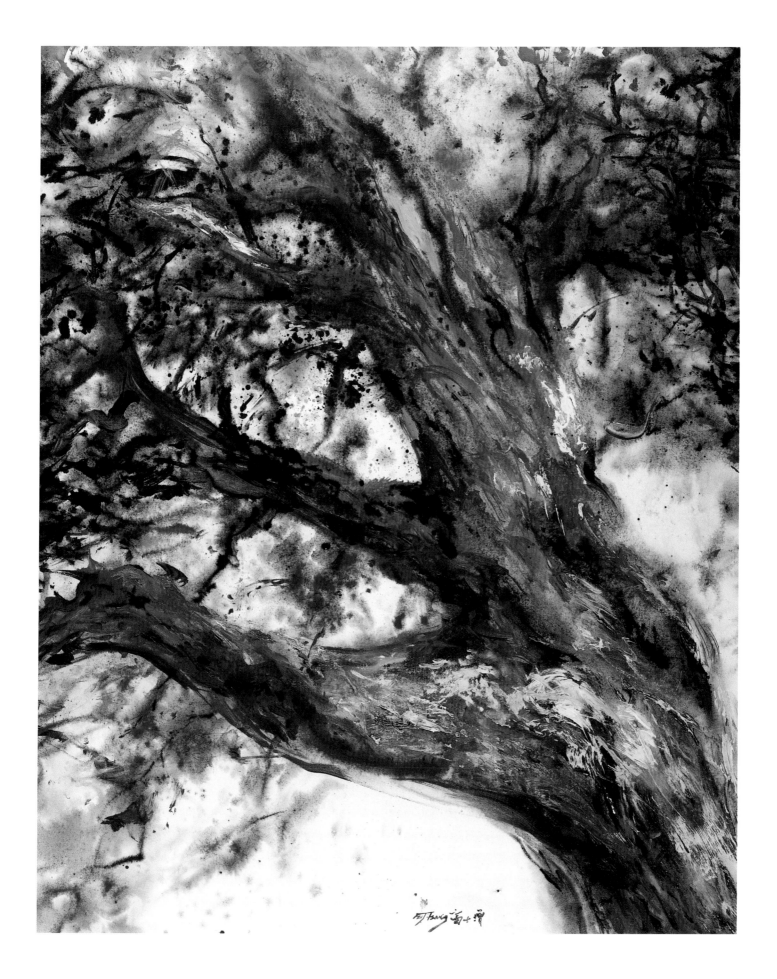

枥
樹 OAK

Where'er the oak's thick branches stretch
A broader browner shade;
Where'er the rude and moss-grown beech
O'er-canopies the glade,
Beside some water's rushy brink
With me the Muse shall sit, and think.

THOMAS GRAY

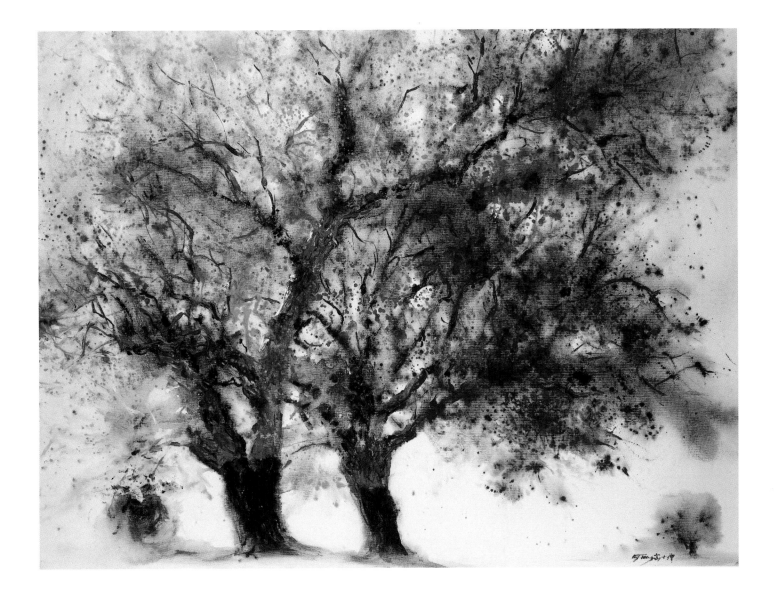

WINTER

Where am I going? Where can one wish to go in winter?
I precede spring, I precede the sun … it shines in my eyes like
the tinted mists of the East.

Gérard de Nerval, from *Voyage en orient*

兰花 ORCHID

ON AN EVENING STROLL IN THE LÜ-YAN PARK
I GO UP THE NING-TS'UI PAVILION STEPS

The remnant of spring is far gone,
Green water overflows the new pool.
Love for the dense forest shadows is aroused in us;
First whiff of cool orchid breeze.
On the high street I can see on all sides;
Endless long green hills surround the city.
Wilderness tints improve in the evening,
Misty sunset is subtle and vague.
Lonely longings cannot be set down.
Alone I sing: with whom shall I toast the wine?
Bright moon seems to comfort me,
Open the alcove and let in the pure light.

OU YANGXIU
Translated from the Chinese by Amitendranath Tagore, *Moments of Rising Mist:
A Collection of Sung Landscape Poetry*, Grossman Publishers, 1973.

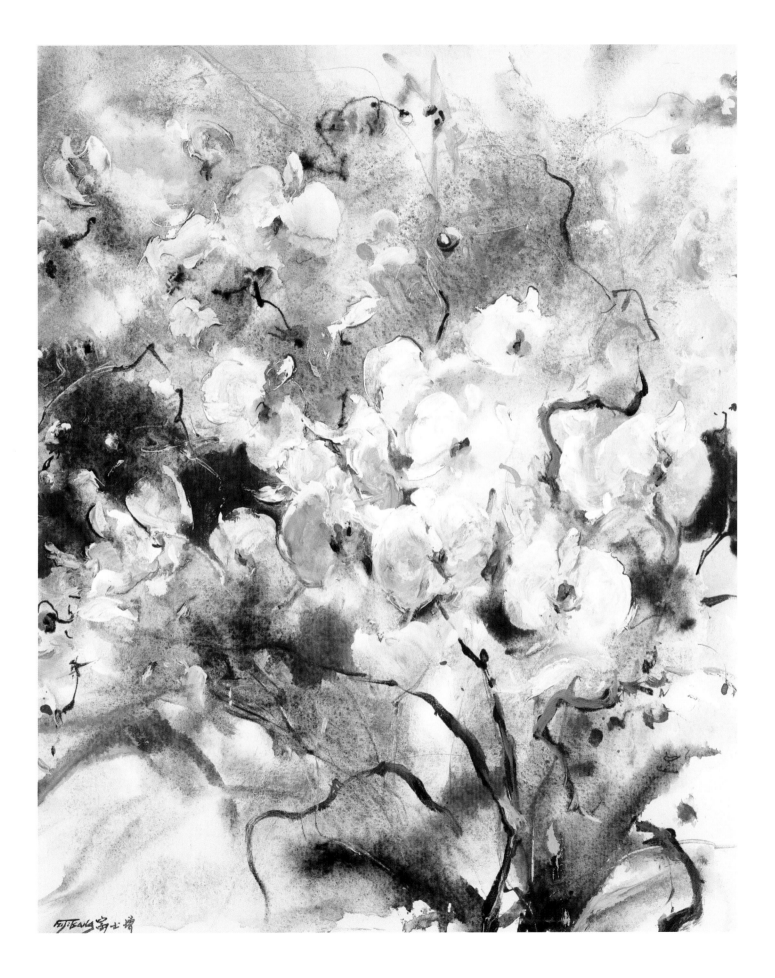

IN ANCIENT CHINA, wild orchids decorated and perfumed the interiors of houses. During the Song dynasty, the orchid was recognized as one of the "four friends," along with the bamboo, the plum tree, and the pine. With its long deep green leaves and delicate flowers, supported by an apparently delicate stem, the orchid demonstrates immense gracefulness.

ORCHIDS grow in inaccessible areas high in the mountains, and thus symbolize the purity to which every scholar aspires in the search for knowledge, desiring not to be corrupted by worldly concerns. What better symbol for the scholar than this refined, slightly haughty flower?

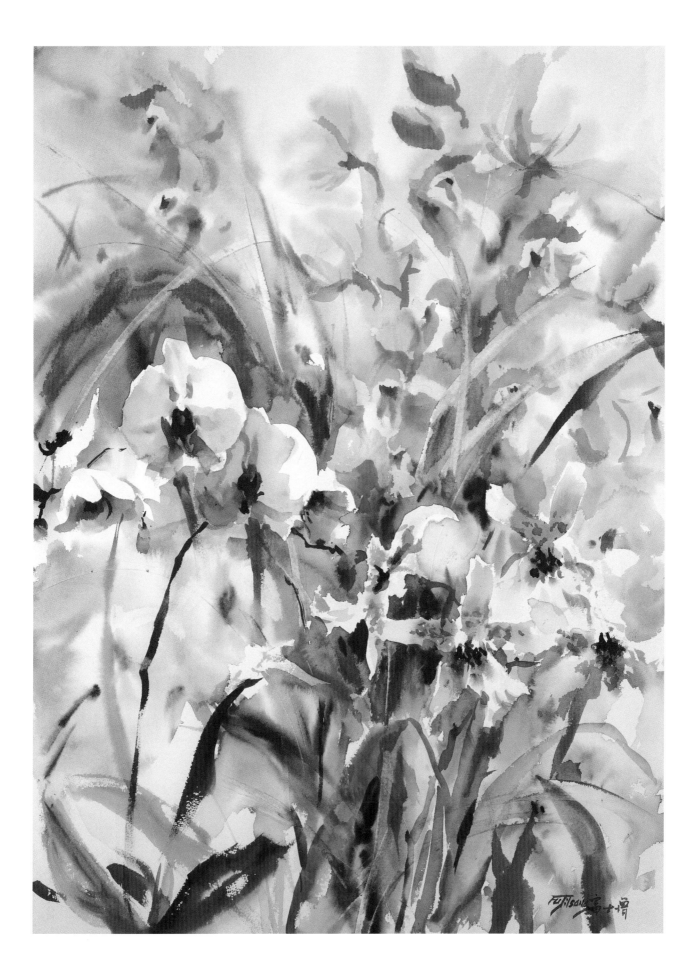

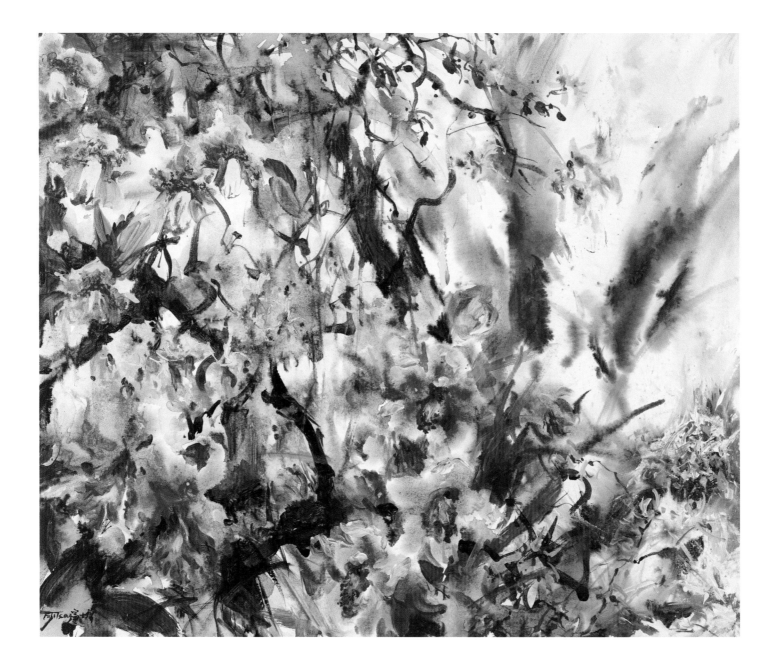

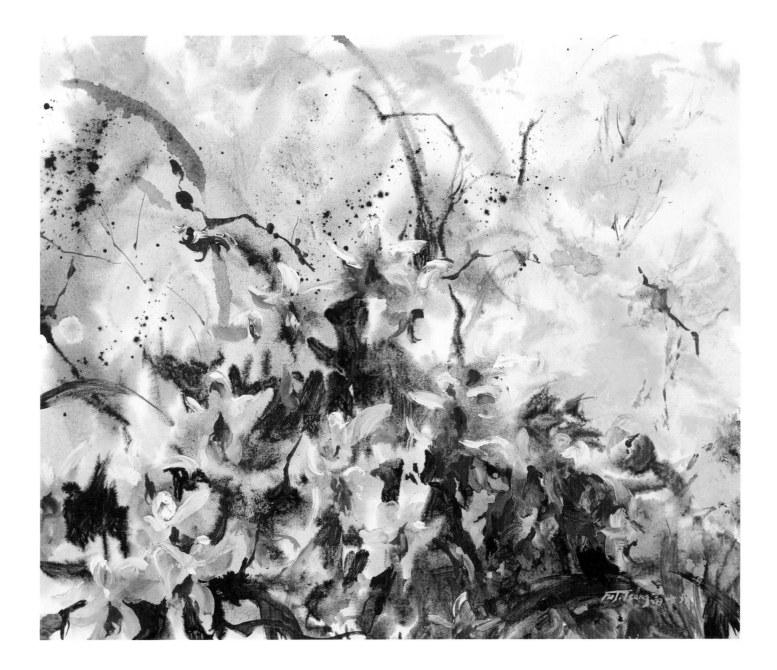

FOLLOWING CHINESE TRADITION, I slowly mix ink and water to obtain a dense texture. Calmly I dip the brush into the water, then skim the ink with its tip. Each brushstroke on the rice paper depicts a leaf with variations in light and shade; each curve is a balance of tension and release. Here, there is no place for mistakes or fresh starts. This seemingly simple style hides an implacable discipline.

Using variations in the black of the ink and different brush movements, the ancient Chinese masters managed to suggest the colors, leaf composition, roots and petals of the orchid. In their works, each leaf is supple and vigorous, each petal elegant. All brushstrokes must be carefully thought out, for, according to the Chinese proverb, "a brushstroke is as heavy as a thousand ounces of gold." In a complex composition, several misplaced brushstrokes may go unnoticed, but when depicting a solitary subject like an orchid, a single clumsy stroke stands out immediately.

"The cold forces it to flower instinctively in order to survive— a little like a challenge to destiny."

SOME ORCHID-LOVING friends have shown me tiny wild tropical orchids growing next to exuberant cattleyas in their greenhouses. Despite its fragile appearance, the orchid is able to resist hostile environments. The cold forces it to flower instinctively in order to survive—a little like a challenge to destiny. Orchids fascinate me. Their colors and fragrances intoxicate me. I can paint them for days on end when I enter their universe. What force prompts me to use these colors that give this intensity to my paintings?

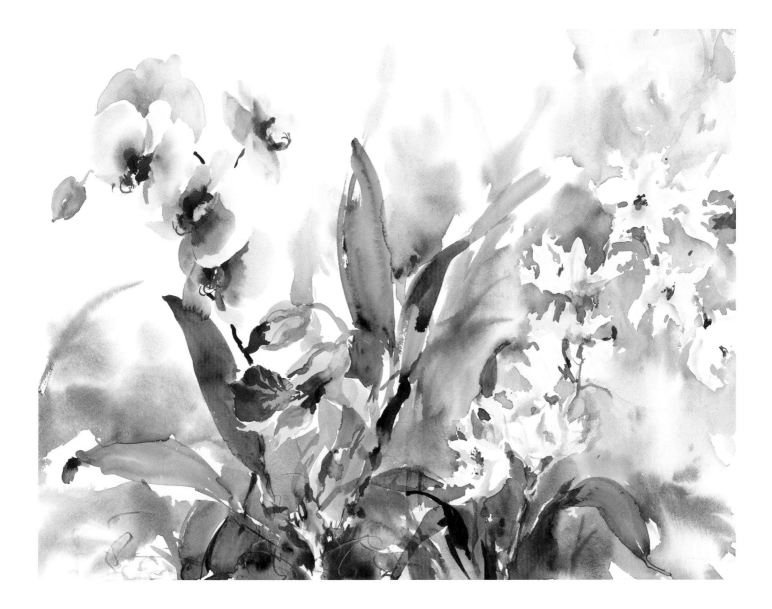

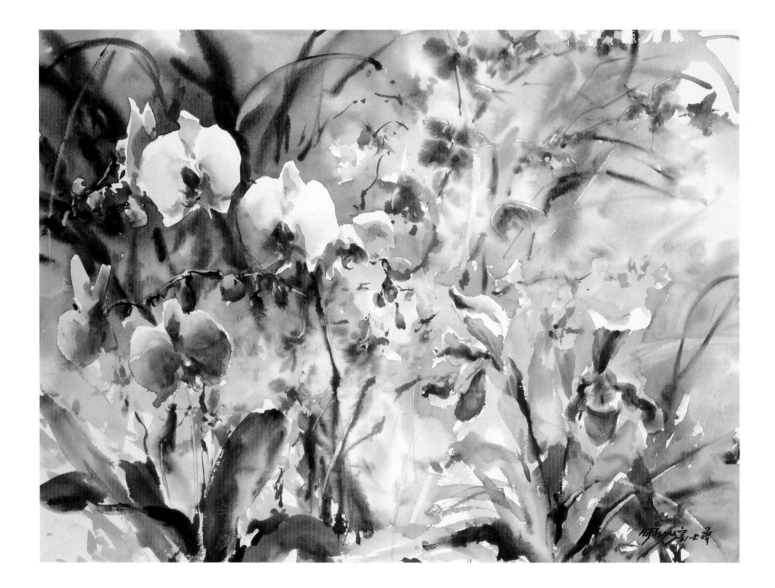

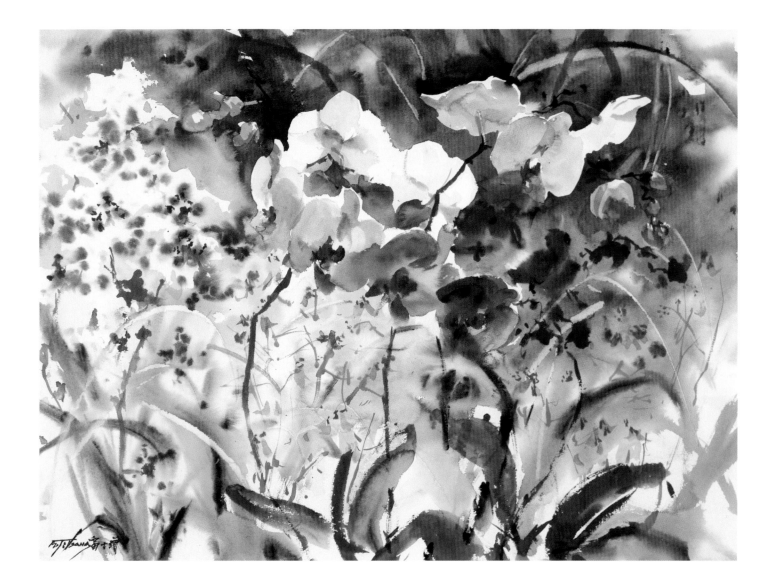

CYPRESS

I keep seeing you, still cypresses,
In the harsh light,
Outlined against azure, on the edge of the waves, near
A white barrier:
I also remember the dead; it's taken on your color,
My soul, a dark abyss.
But I cast myself out of the reach of Destiny and despair,
Like your summit.

JEAN MOREAS

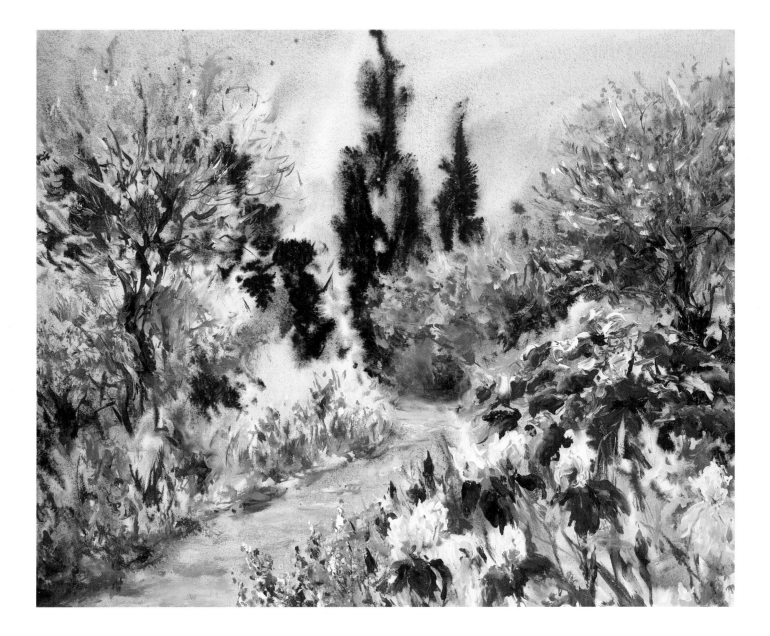

CERTAIN TREES surprisingly inspire the same feelings in the four corners of the world. In China, as in the West, the cypress symbolizes immortality and inspires introspection. Its tightly fibered, resin-filled wood, its constant greenery, its long sober silhouette, and its longevity have earned it the name "tree of life." For the Greeks and Romans, the cypress was identified with Hell. This tree of the Underworld is planted in the cemeteries of Mediterranean countries. I have a particularly vivid memory of cypresses several centuries old growing in Confucius's sanctuary in Qufu, the philosopher's village of birth. Two cypresses with fossilized trunks stand guard at the entry of this sacred place. Supported by concrete poles like two elderly men resting on walking sticks, they proudly display their foliage, sparse like thinning hair. They incarnate the legacy left by the philosopher 2,600 years ago.

"How do I share my emotion?"

THE CYPRESS inspires boldness and exaltation. André Derain admired its extraordinary force, and his works painted in the south of France bring out this quality. Here, the forms and colors become a veritable elegy to Nature.

GEORGES BRAQUE and Raoul Dufy also painted these southern landscapes with stylized cypresses according to Fauvist or Cubist tendencies. One thing remains constant among these painters: a passion for Mediterranean flora. Braque even remarked: "It is in the Mediterranean that I felt all my exhilaration spring forth. Just think—I had left the sad, dark Parisian studios where painters still work on bitumen. And here, what a contrast, what a revelation, what fulfillment!" When I travel in this region, the same exaltation fills me. Beyond the trees, the flowers and nature, is this very strong feeling of happiness and joy that I would like to convey in my works. How do I share my emotion? I have the impression of lacking the means; I need time to absorb and feel everything. I envy these cypresses for their long life and the wisdom time brings them.

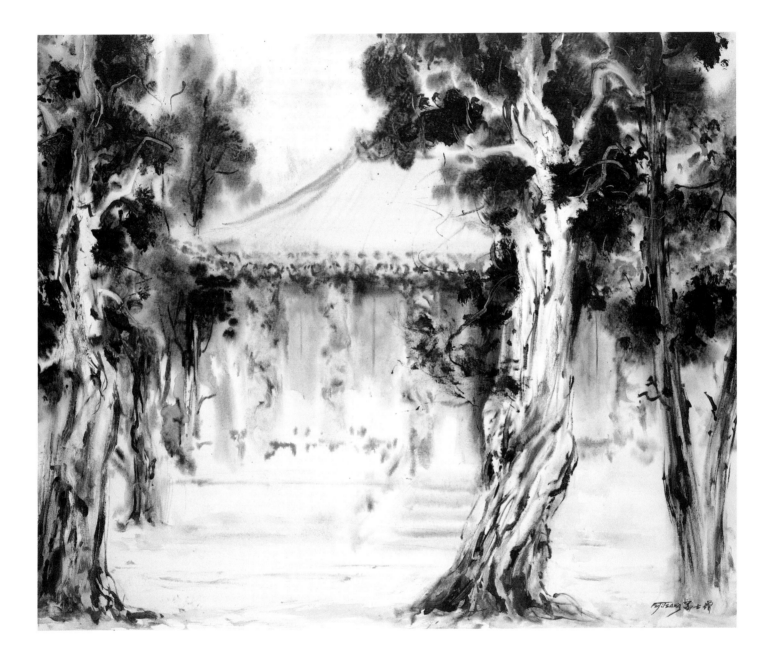

水仙

NARCISSUS

THE NARCISSUS is a bulb plant that lives for a large part of the year under the earth, like Persephone, the maiden from the ancient Greek legend who, after picking a blue narcissus, was dragged to the subterranean kingdom of Hades, god of the Underworld. The Greeks place these flowers on their tombs. While associated with death, the narcissus' hardiness also allows it to symbolize eternal youth and the hope of renewal. After all, are not death and life the two halves of the same reality?

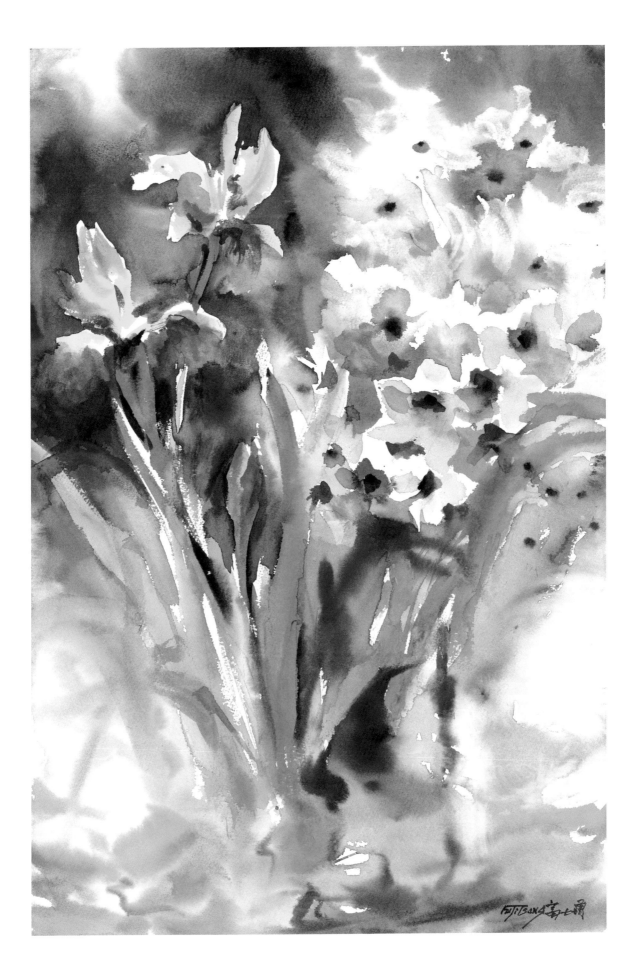

BAMBOO

IN A RETREAT AMONG BAMBOOS

Leaning alone in the close bamboos,
I am playing my lute and humming a song
Too softly for anyone to hear—
Except my comrade, the bright moon.

WANG WEI
Translated from the Chinese by Witter Bynner, *Jade Mountain*, Alfred Knopf, 1919.

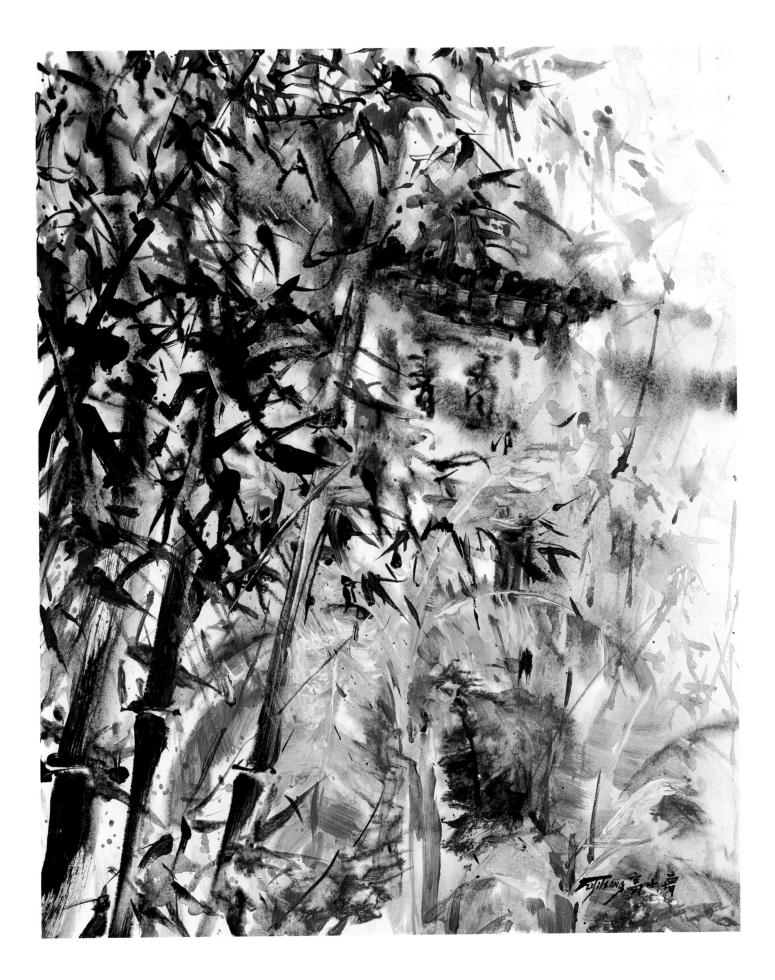

THE CHINESE use bamboo in all domains of life: in architecture, as scaffolding for construction, in furniture, and in cooking utensils. Rolled sheets of bamboo also constituted the first writing materials in ancient China, later to be replaced by paper made of bamboo fibers.

IN CHINESE ART, the straightness of the bamboo symbolizes human rectitude. Is it because of the bamboo's undeniable usefulness that humans identify this plant with virtue, or is it because its unique silhouette inspires this association? For the Chinese, the study of painting often begins with a representation of the bamboo, an exercise that teaches the rhythm of movement and allows gestures to develop. "Before painting a bamboo, may a bamboo already grow in you!" recommended the celebrated eleventh-century scholar Su Dongpo.

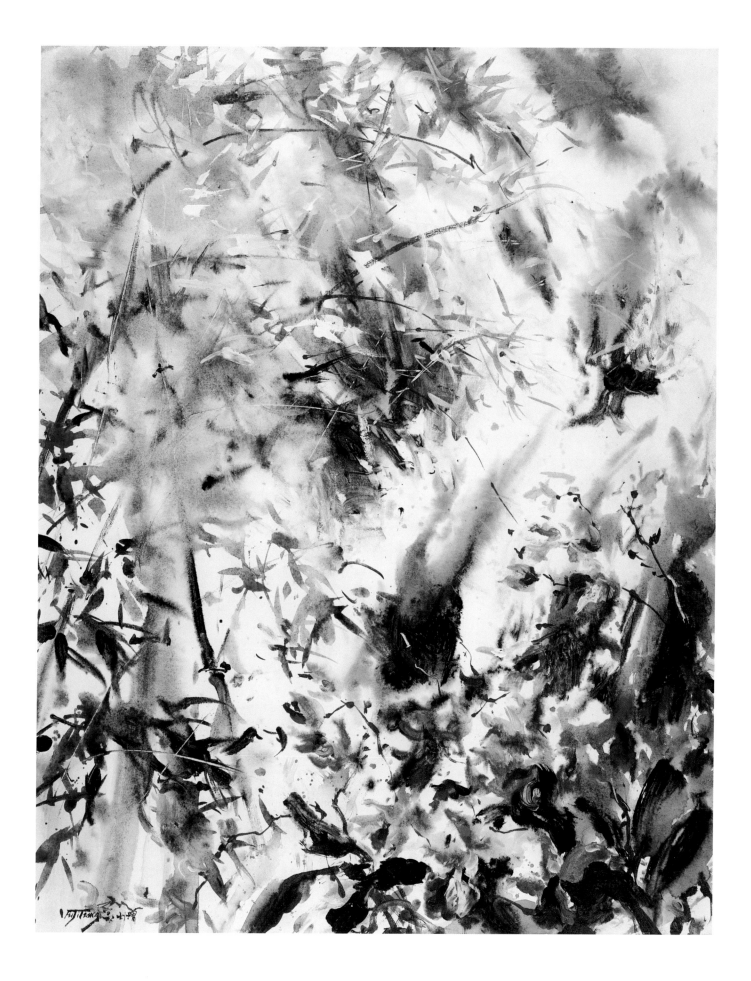

I BEGAN PAINTING the bamboo very early, like many pupils in China, without observing it in nature and without understanding its symbolism. The stems I painted were stiff and unenergetic, the leaves mere repetitive forms. I failed to bring this subject to life and soon lost interest in it. One morning, my teacher took me to the Blue Bamboo Park in the west of Beijing. There, in the dew-moistened prairie, giant bamboos stood alert like a tense, motionless army. Looking as if they had been set in Ming porcelain, arm-long stems, both streaky and smooth, rose to the sky. Their branches, similar to arrows, displayed leaves that were blue-green on one side, pale green on the other. I crouched down to the ground to examine a bamboo shoot that had newly emerged from the earth. I then felt the intense energy contained in this plant that paradoxically appears so serene. It was from that moment that I discovered the bamboo's intrinsic beauty. Over the years, my studies and compositions have tended to depict the qualities that I myself would like to possess.

"'Before painting a bamboo, may a bamboo already grow in you!'"

I KNOW A BAMBOO garden in Provence where I take great pleasure in strolling. Dozens of acres of bamboo plants from all continents live in harmony here, amidst a silence interrupted only by the rustle of footsteps on dead leaves. It was here, at the Bambouseraie d'Anduze, that one day I came across someone who found these tightly arranged, sometimes impenetrable straight stems to be monotonous. I suggested that he see these bamboos as symbols of living beings. Seen in this light, the wind, rain, drought and frost take on the status of fierce survival tests. Do we have the strength and rectitude to face life's trial's like the bamboo?

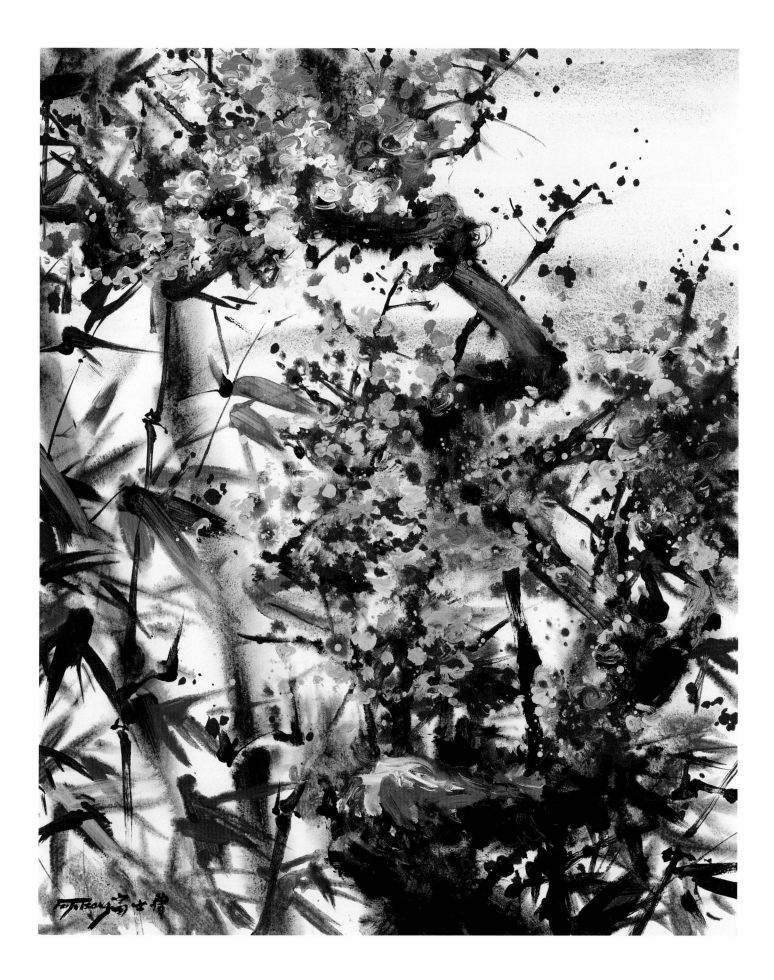

PLUM TREE

ON A WALK IN THE EARLY SPRING HARMONIZING A POEM
BY MY FRIEND LU STATIONED AT CHANGZHOU

Only to wanderers can come
Ever new the shock of beauty,
Of white cloud and red cloud dawning from the sea,
Of spring in the wild-plum and river-willow ...
I watch a yellow oriole dart in the warm air,
And a green water-plant reflected by the sun.
Suddenly an old song fills
My heart with home, my eyes with tears.

DU SHENYAN
Translated from the Chinese by Witter Bynner, *Jade Mountain*, Alfred Knopf, 1919.

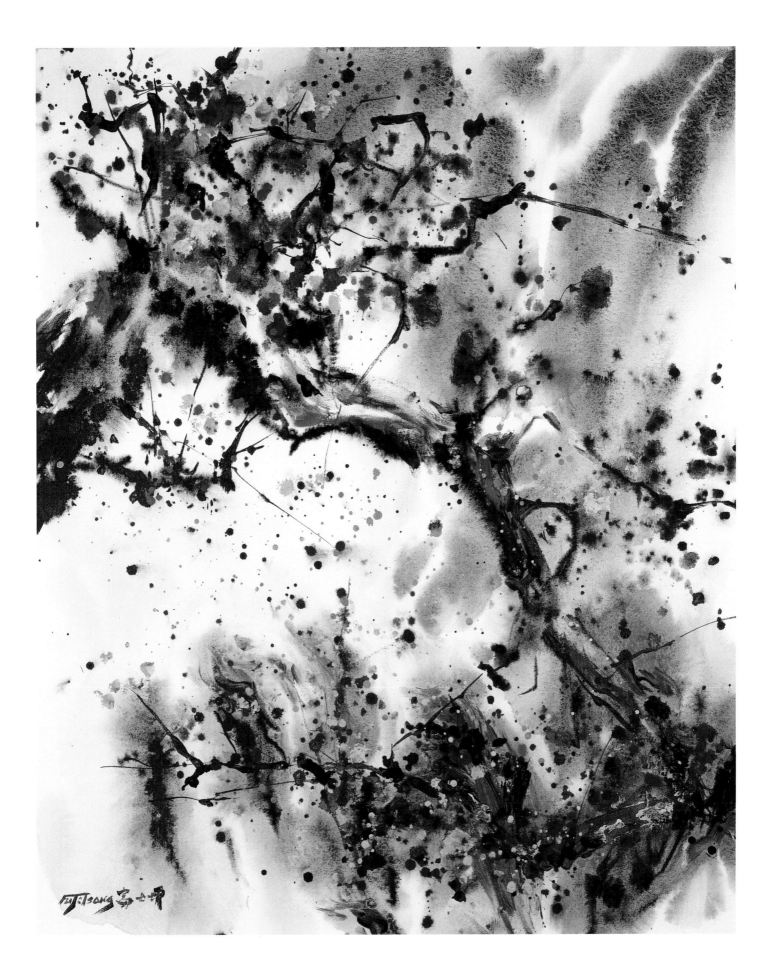

THE WILD PLUM TREE, called the *mei* in China, has a very hard trunk covered in a deep brown, almost violet bark. It manages to grow in the most hostile terrains and decorates the slopes with its gnarled branches. From February onwards, buds appear under the snow and ice, later to be transformed into bunches of red, pink, or white flowers. For those taking a walk in the first days of spring, what a joy to see these splashes of color in a barely awakened landscape!

"From February onwards, buds appear under the snow and ice …"

LIKE BEAMS OF LIGHT, plum blossoms delight us with their thousands of petals in tender tones and pastels. It is after blossoming that pointed leaves appear. Capable of living a thousand years, this tree grows ever more beautiful over time. The Chinese see it as a symbol of nobility and human resistance in the face of adversity.

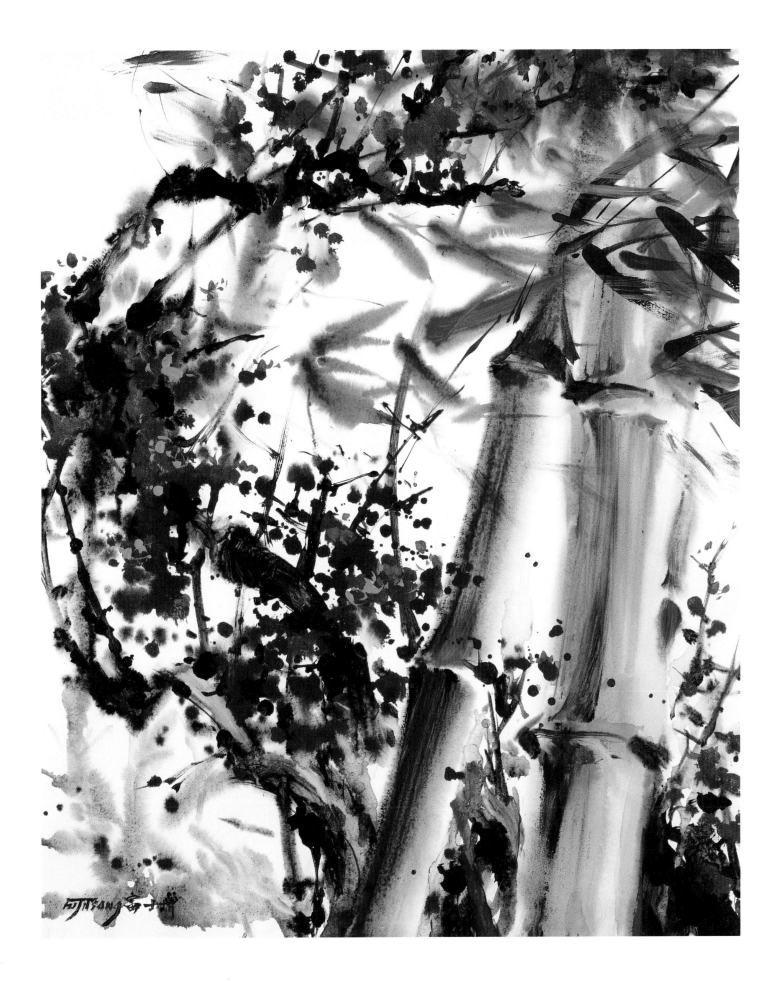

ACACIA

from THE SPIRIT OF SOLITUDE

Like clouds suspended in an emerald sky,
The ash and the acacia floating hang
Tremulous and pale. Like restless serpents, clothed
In rainbow and in fire, the parasites,
Starred with ten thousand blossoms, flow around
The grey trunks, and, as gamesome infants' eyes,
With gentle meanings, and most innocent wiles,
Fold their beams round the hearts of those that love,
These twine their tendrils with the wedded boughs
Uniting their close union; the woven leaves
Make net-work of the dark blue light of day,
And the night's noontide clearness, mutable
As shapes in the weird clouds.

PERCY BYSSHE SHELLEY

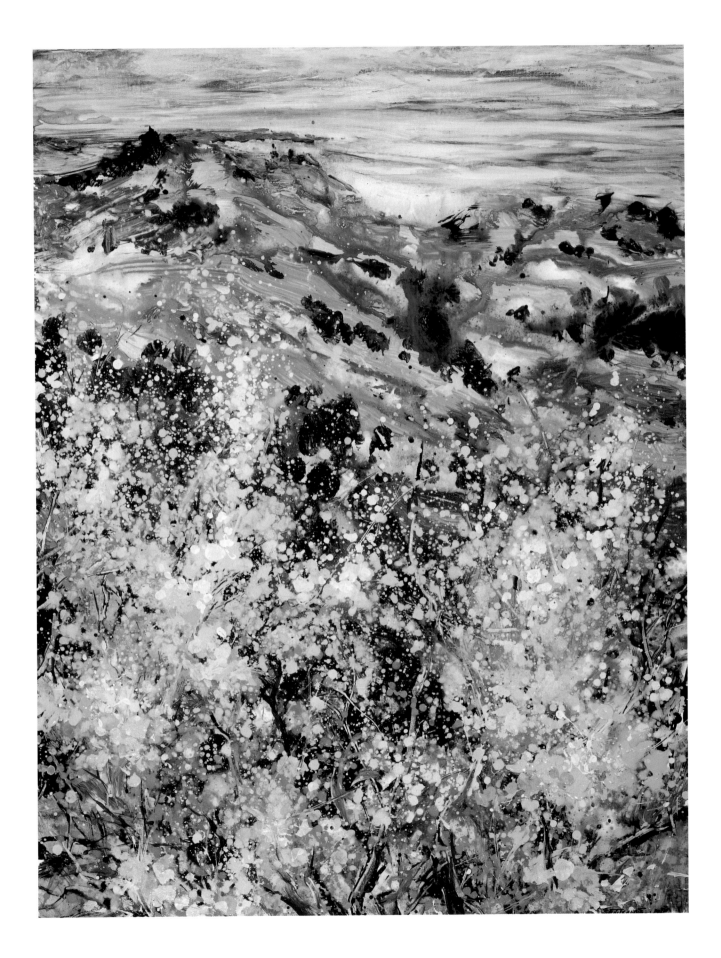

FROM THE FAMILY of Leguminosae originating from Australia and commonly called mimosa, certain species have thorns on their branches, earning them the name "acacia." *Kakia* in Greek means vice and dishonor, while the prefix *a-* indicates a negation. "Acacia" thus figuratively becomes the antidote to vice and evil. According to legend, Noah's ark was constructed from acacia wood because it resists rotting and is considered noble and sacred.

FROM THE END of January, a time when Nature wears a drab coat of dry branches and dead leaves, bunches of yellow baubles appear on the mimosa. From afar, the trees seem to be covered in gold. The intoxicating yet subtle fragrance of this flower combines with a symphony of colors—the intense reds and ochers of the soil in Estérel in southern France, the different yellows of the flowers, the pure greens of the mimosa leaves, the infinite blues of the sky. The senses come fully alive … heat flows through me and makes me forget the winter.

YET WINTER is really here. One need only take the road to Tanneron to see a surprising contrast. The deep blue Mediterranean coast brings out the yellow on the slopes. The glowing mimosa branches bend towards the road, welcoming visitors, or else stand upright like a firework display. Suddenly, after turning a curve, the decor changes. The snowy summits of the southern Alps, sparkling with light, emerge from behind the yellow splashes of the mimosa. Between sea and mountain, passing through an infinite range of colors, the countryside spreads out, dotted with villages and hamlets. The horizon stretches out in the distance and my eyes sweep across it from east to west without encountering a single obstacle. Pure beauty surrounds me, from the intense blue sky to the red earth, down to my feet partially covered in golden baubles.

AFTER FINISHING a series of studies, I return to my studio with a few golden mimosa branches. Under the blue sky of the Côte d'Azur, its yellow balls are like little suns that radiate before my eyes. Some painters disdain this flower for the tediousness of its yellow. I, however, find a multitude of nuances in its color. Its gold is so intense that it influences and transforms all surrounding colors, bringing life to the whole composition.

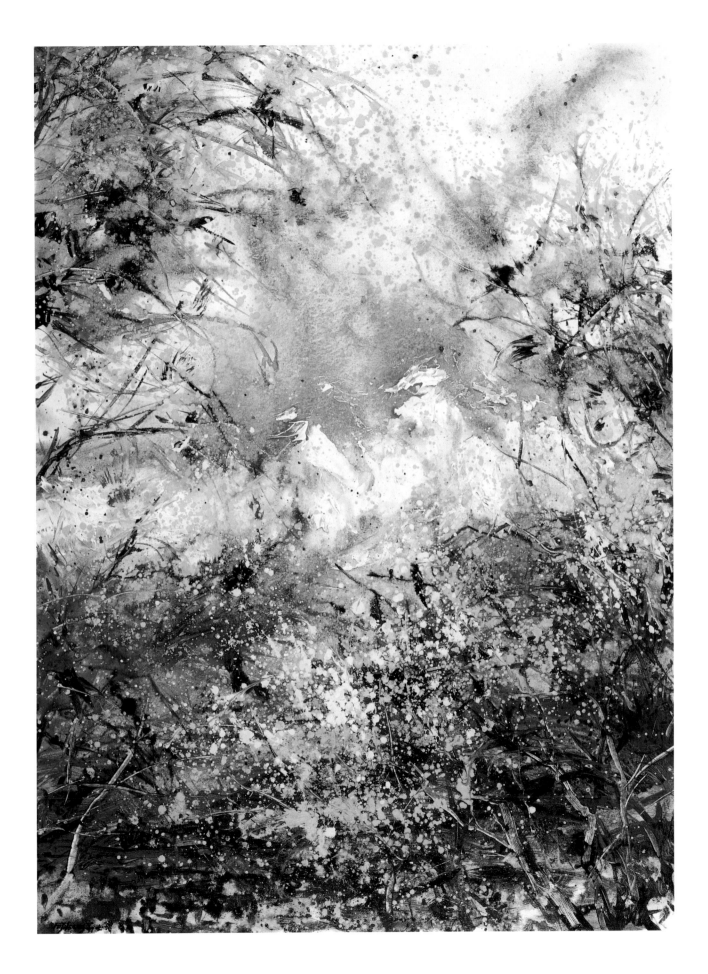

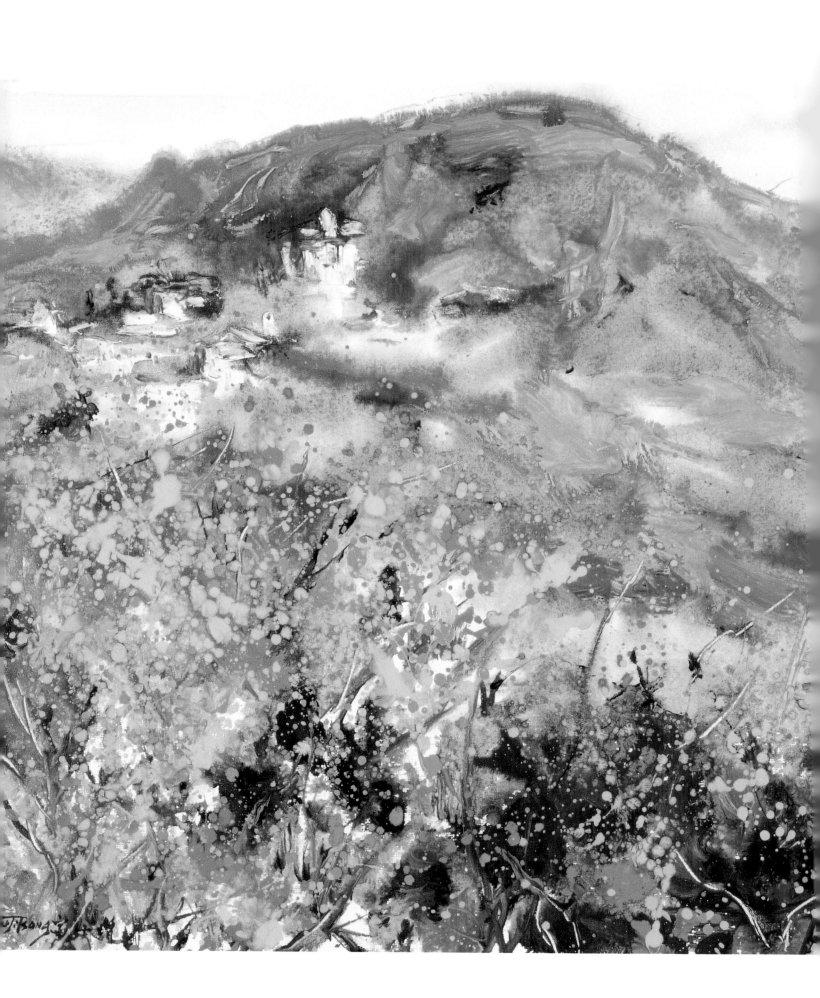

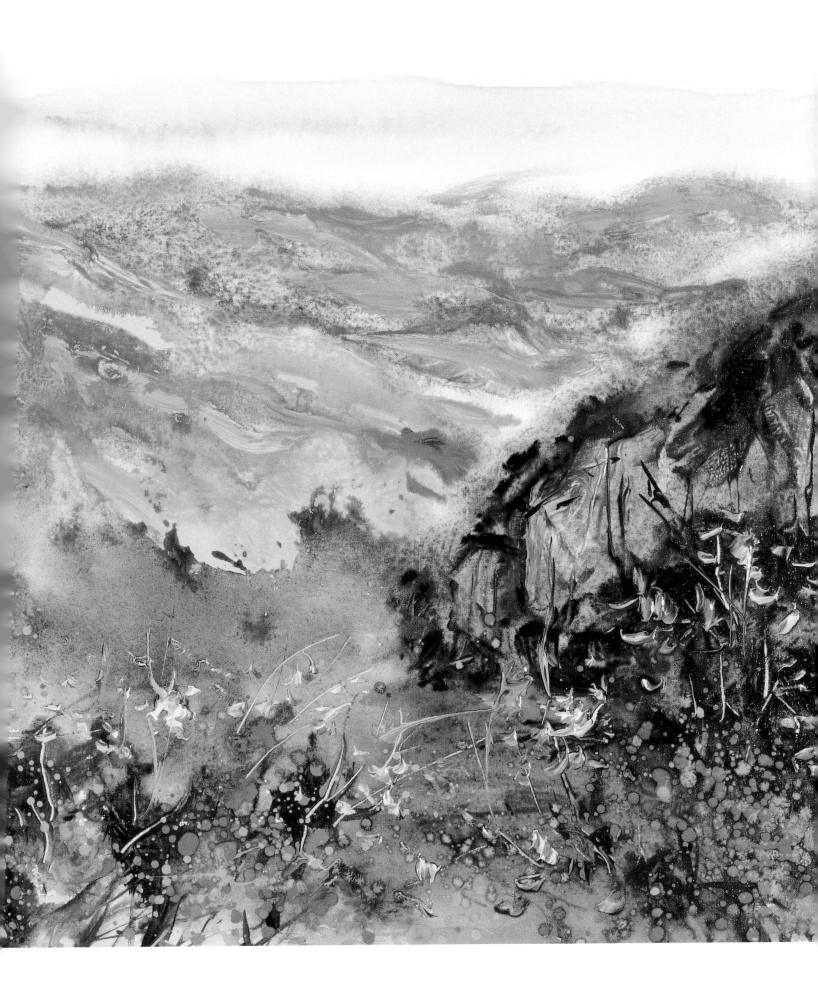

GINKGO BILOBA

This tree's leaf that from East
To my garden's been entrusted
Holds a secret sense, and grist
To a man intent on knowledge.

Is it one, this thing alive,
By and in itself divided,
Or two beings who connive
That as one the world shall see them?

Fitly now I can reveal
What the pondered question taught me;
In my songs do you not feel
That at once I'm one and double?

JOHANN WOLFGANG VON GOETHE
A poem dedicated to Marianne von Willemer, 1815.
Translated from the German by Michael Hamburger and Christopher
Middleton, *Selected Poems*, edited by Christopher Middleton,
John Calder, 1983.

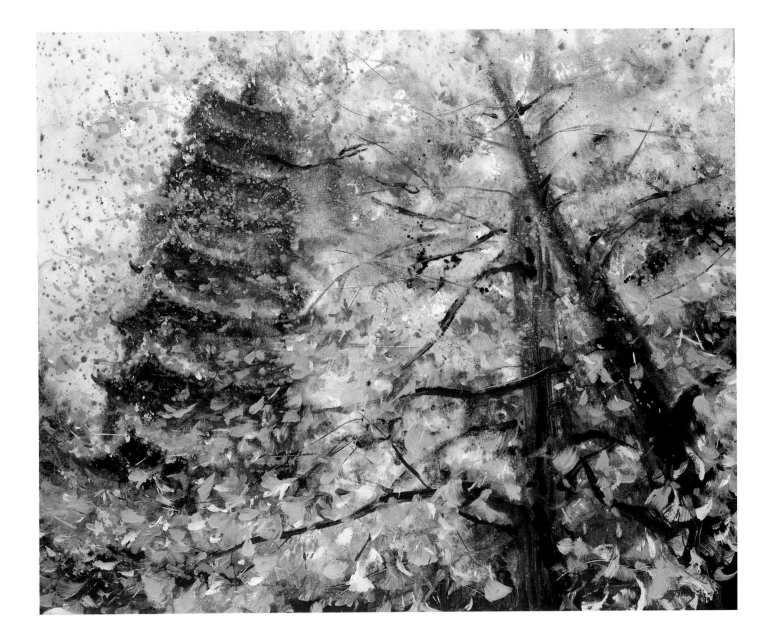

HAVING EXISTED for 250 million years, this venerable tree of extraordinary longevity and vivacity is considered a sacred essence in China. For thousands of years, the Chinese have planted it in places of worship, taking care to always place a male next to a female.

AT THE JIN TEMPLE in Taiyuan, a place of worship constructed according to Confucian ideals and dedicated to the ancient kingdom founders, two immense ginkgoes stand majestically upright. With trunks so wide that the arms of three people could not encircle one of them, these trees extend their branches to offer shade and refreshment. Under the sunlight, their leaves, whose shape recalls the fans of Egyptian pharaohs, are a gentle green in spring. These leaves gradually deepen in hue in summer to contrast with the dark branches. In the fall, the foliage takes on a marvelous golden color. When winter arrives, it is said that all the leaves fall in one night.

"… I could not resist painting the ginkgo leaves."

DURING A VISIT to this temple one spring day, inspired by so much beauty, I could not resist painting the ginkgo leaves. Visitors to the temple seemed drawn to the feet of these two trees, touching, caressing and hugging them as if they wanted to commune with them. Planted by noble lords more than 650 years ago, these trees have remained the unchangeable witnesses of changing times and social transitions. While our world unceasingly accelerates its development with little regard for Nature and the order of things, these trees remind us of continuity and permanence. In a thousand years, they will perhaps still be there when the temple may well have disappeared. But if they are destroyed like the temple of Hiroshima, I want to believe that they will be born again, like phoenixes that rise again from their ashes—a symbol of life and eternal renewal.

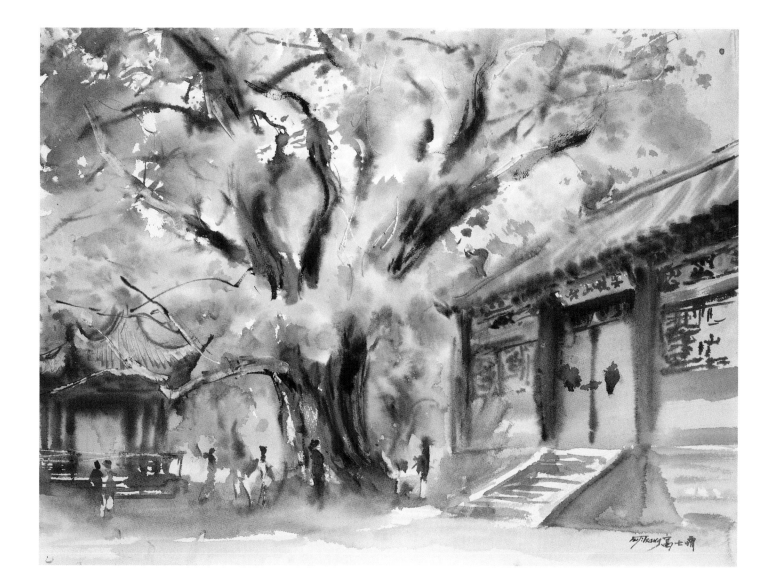

BIOGRAPHY

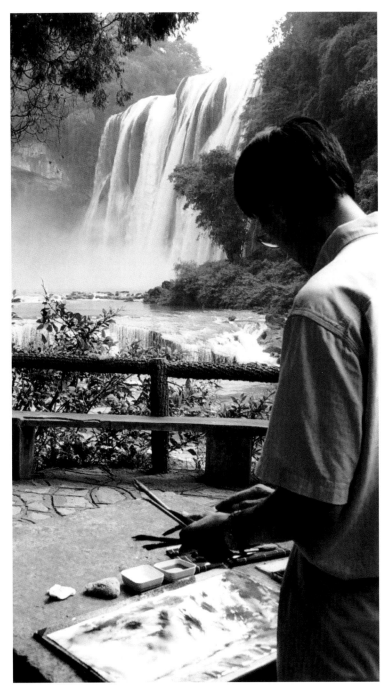

The artist at work by the Huangguoshu waterfall.

1958 Fu Ji Tsang was born in Beijing on June 22, 1958.

1966 The Cultural Revolution begins as Fu Ji Tsang enters primary school. This marks the start of a difficult period for his family.

1968 As art is not taught at school, his parents arrange for him to have private drawing and music lessons.

1970 His father is sent off to Gansu province to be "re-educated," while the young Fu Ji Tsang is subjected to increasingly appalling treatment from schoolteachers who are fanatic followers of the Cultural Revolution ideology.

1973 At the age of fifteen, he is also sent to the countryside to be "reeducated." To escape from this painful and heartless reality, he takes refuge in painting. Among the great European schools of painting he discovers at this time, he is most impressed and inspired by French artists: the Romantics, the Barbizon school, the Impressionists, the Postimpressionists and the masters of modern art. Using these artists as his models, he devotes himself to numerous series of studies.

1974 The family takes the risk of asking for a visa to settle in Hong Kong.

1975 A terrible earthquake in Tangshan afflicts the capital and destroys the family home. Two weeks after the disaster, they obtain their visa for Hong Kong. They depart secretly, leaving behind the few belongings that the earthquake has spared.

1976 Arrival in Hong Kong. Fu Ji Tsang takes French lessons in order to realize his dream of studying art in France. All his free time is spent creating about a hundred studies on Hong Kong's ports and quays.

1978 At the age of twenty, he wins first prize in a competition for young Hong Kong artists. This victory fuels him with even more determination to make art the center of his life.

1979 First exhibition at Minden Plaza Gallery in Hong Kong.

Fu Ji Tsang is accepted into the École Nationale d'Art Décoratif in Nice, France. Upon arrival in Paris, he visits the capital's great museums.

1980 While training in the École's Art Department under Dolla and Eppelé, he studies the technique of lithography and produces a series of lithographs on stone named *Les Quatre Saisons*.

1981 Over the two-month summer break, he travels in Europe, visiting great museums, immersing himself in the masterpieces, and discovering the diversity of landscapes, cultures, and

architecture. He takes photographs of works, notes his impressions in a journal, and makes a number of sketches.

1983 He enrols in the École's Environmental Department to study architecture and landscaping under the architect Schemltz. The Museum of Saint Paul de Vence exhibits his paintings.

1984 After meeting the gallery owner Pierre-Helen Grossi, he exhibits paintings on the theme of Haute Provence in Apt.

In the same year, his sculptor friend Jean-Pierre Augier invites him to exhibit in the village of Levens.

1985 He obtains his diploma with honors, after submitting a project to create a garden on the banks of the Paillon River. This project links his major in environmental studies with his passion for art, by presenting his ideas not only through plans and models, but also through large-format watercolors.

In the summer he accompanies four hundred young French people on a trip from Paris to Beijing—this is the first time that he returned to his country of birth.

1986 He decides to live in the south of France for the magic of its colors and light.

First exhibition in the Art'Nold Gallery, Nice—a gallery that is subsequently to include his works in its permanent collection.

1987 Originally working in oil and acrylic paints, he gradually makes greater use of watercolors. He paints large formats to show that watercolor is a unique artistic technique that deserves recognition in its own right.

One of his watercolors wins second prize in the Mossa competition.

1988 He exhibits at the municipal Mossa Gallery in Nice.

When his friend Maurice Perrier publishes *Le Clavier intempérant*—an anthology of fifty-two poems—Fu Ji Tsang illustrates each limited edition copy with an original watercolor.

He wins third prize in the Mediterranean Art Competition.

1989 Fu Ji Tsang shows sixty large-format paintings in the Bernanos Gallery in Paris. He also exhibits in Beaulieu-sur-Mer at the Via Aurelia Gallery, whose owners Nicole Durand and Marie-Claude Planel become his close friends.

At the Espace Bonnard in Cannet, painting and music come together when his exhibition opens with a classical music concert given by a quartet from Nice Philharmonic Orchestra.

Z'éditions publishes a book of his works called *Montagne et Eau*. The first copies are accompanied by an original watercolor.

1990 Mr. Kobler, director of the Unissys international center in Saint Paul de Vence organizes an exhibition of his works.

1991 Luo Liping, General Consul of China, and Madame Dezbazeille, Mayor of the seventh district in Lyon, open an exhibition at Espace 35 during the Biennale of Contemporary Art of Lyon.

Selected by the jury of the twenty-fifth International Prize of Contemporary Art of Monte Carlo, Fu Ji Tsang presents a triptych watercolor called *Les Alpes de mes rêves*, 134 x 61 inches (3.40 x 1.55 m).

The Hong Kong newspaper *Dagon Bao* praises his paintings during an exhibition of his works at the Cultural Center of Hong Kong.

His paintings are then presented in Singapore at the Asian Arts Gallery, which also publishes a work on the painter in four languages, accompanied by poems by André Verdet.

Noted for his computer graphics work, he is invited to take part in the exhibition *Rencontre d'Art Infographique* at the Centre Georges Pompidou in Paris.

1992 Numerous exhibitions featuring the flowers and landscapes of the south of France—the subjects of his latest research—take place in France and overseas. His works are shown in the Frères Gallery, Strasbourg, the Guin Richelme, Marseille, the Différence, Antibes and the Via Aurélia, Beaulieu-sur-Mer. He also exhibits in Saint Pierre and Miquelon in Canada, under the patronage of the North Atlantic Council General and Radio Atlantic.

With French artist André Verdet and gallery owner E. Pons in 1989.

1993 In May, the UNESCO bulletin dedicates its second page to one of his watercolors *Ombre et Clarté*.

The Town Hall of Villefranche-sur-Mer exhibits his works in Sainte Elisabeth Chapel in April. The Carlton Gallery in Cannes shows his large formats in July. The Art'Nold Gallery in Nice presents his creations on the theme of "Alps and Azure" in August; the artist produces four lithographs for this exhibition.

Aubusson Tapestries, in conjunction with Robert Four Gallery, selects Fu Ji Tsang's work *Les Jonquilles* to create an entirely hand-woven tapestry (limited edition of eight copies). Since then, over twenty subjects have been woven by Aubusson.

1994 In February, he is invited to show in the Guin-Richelme Gallery in Marseille.

In June, Frédéric Dupont, former minister and mayor of the seventh district, shows the artist's works in the Town Hall. René Percheron, a former employee of the Musées de France and a long-time friend, presents a film on the theme of "Painting and the Garden, Highlights and Features of Chinese Civilization."

His works are exhibited in the Eze Museum and the Rocambole Gallery.

He is asked by Gilbert Lapeyre to design the poster of the Festival of Dancing Nights in Nice.

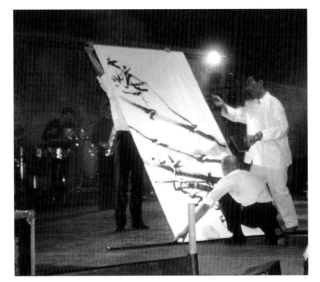

At the Théâtre de Verdure in Nice, 1996.

1995 An exhibition of his works opens at the Riviera Gallery in Mougins, and is attended by the mayor, Roger Duhalde.

In October, the Gothic Room of Saint-Émilion—and its surrounding vineyards—play host to his watercolors depicting the landscape of Bordeaux.

1996 With his musician friend Philippe Bertaud, he invents the concept of the concert-performance whereby he improvises and creates a large work accompanied by music, while the public looks on. The first concert-performance, based on the theme of water, takes place in La Gaude, France in April.

In June, the Espace Bonnard in Cannet hosts an important exhibition of Fu Ji Tsang's paintings, under the patronage of the mayor Michelle Tabaro.

In Hong Kong, the Shan Shi Xuen Gallery dedicates an exhibition to his works.

As President of the artists' group "Formes et Muraux", he collaborates with the municipality of Grasse in programs for the cultural development of the town's historic quarter.

At the end of the year, he sets up his studio on the ramparts of Antibes, an exceptional location facing the Mediterranean Sea and just next to the Château Musée Picasso.

1997 Fu Ji Tsang takes part in the International Salon of Contemporary Art Direct'Art in Nice, along with six hundred exhibitors and artists from all over the world.

March marks the beginning of a collaboration with the Terre des Arts Gallery, which is subsequently to exhibit his works every year.

In summer he gives a number of concert-performances.

In Villeneuve-Loubet, he creates *Les Gorges du Loup*—a large watercolor that then inspires a screenprint, *Source de vie* in honor of women and nature.

In the fall, with the help of his American friend Russell Dusek, he takes part for the first time in the Art Expo in New York. The Cat Black Gallery, West Port, New Jersey then invites him for a personal exhibition.

1998 The municipality of Tarascon invites him to show his latest works on the theme of orchids at the Cloître des Cordeliers.

For the first time, he takes part in the Art Expo in Los Angeles and discovers California.

From 1998, he begins returning to China once a year to discover inspiring landscapes and to renew ties with the traditions and culture of his native country.

1999 In February, the fiftieth anniversary of the Republic of China and of the Principality of Monaco gives him the opportunity to present thirty works at the Henri Bronne Gallery, in the presence of Mr. Xie, General Consul of China. It is on this occasion that a television channel in Canton broadcasts a report on his life and works.

His works on the body and movement are shown in an exhibition at the Terre des Arts Gallery in Paris.

In April, the Manville Museum in Cité des Baux, Provence presents his paintings on Provence.

In spring, he travels to China to gain new inspiration, visiting Yunnan and the Huangshan—the mountain loved by painters and poets. Here, he accumulates notes and sketches with the idea of publishing a book.

In November, he gives a painting performance in the Museum of Modern and Contemporary Art of Nice, on the theme of "Mountains and Water."

2000 In September, Fu Ji Tsang gives a performance at the Théâtre de Verdure in Nice, on the theme of the Cape of Nice.

"He dreamt of a bridge between two worlds, two civilizations. A symbolic edifice that gains solidity step by step. He comes from a duality that he manages to overcome, combining force of gesture with a rare delicateness," writes the journalist Eva Roque.

In December, he works with musicians and the Off-Jazz dance company to create a performance bringing together contemporary dance, live music and paintings on paper during the first Monaco Dance Forum at the Grimaldi Forum, inaugurated by Princess Caroline of Hanover.

2001 After this rewarding collaboration, he produces a series of paintings on movement and dance energy, shown at Terre des Arts Gallery.

The rest of this year is spent on his book project on China.

2002 *Mes Carnets de Chine* is published by Flammarion in March. For this occasion, the artist creates a series of seven screenprints on the theme of China.

This being the Year of China in Nice, Fu Ji Tsang is the guest of honor at numerous public events. For example, he opens the auditorium of the regional library Louis Nucéra, by creating a painting of the sacred mountain Huangshan.

The city of Nice dedicates an exhibition to his works, *Chine Intemporelle (Timeless China)*, shown simultaneously in three municipal galleries: the first showing large formats; the second, sketches and watercolors; the third, ink works.

At the end of the year, Terre des Arts Gallery presents *Impressions de Chine*, with creations inspired by voyages to his native land.

The Eule Art Gallery invites him to show in Davos, Switzerland.

2003 Two other exhibitions organized by Eule Art Gallery follow in Switzerland: one in Saint Gall in spring, the other in Ascona in summer.

Fu Ji Tsang returns to one of the themes dearest to his heart: the four seasons—an analogy for the cycle of life. His research again draws the attention of Flammarion, which decides to publish his works.

The curator of the Museum of Asian Arts in Toulon, Guillemette Coulomb, offers to organize an exhibition. Fu Ji Tsang decides to show a series of large portraits of Chinese ethnic minorities, along with sketches and texts from his trips. This is the artist's homage to the peoples who make up the mosaic of China.

In September, he travels in the Guanxi and Guizhou provinces of China.

2004 The exhibition *L'Autre Chine* takes place in the Museum of Asian Arts of Toulon from March to August.

In June, a sunrise painting performance takes place in the gardens of this museum with a view over the sea.

In September, Flammarion publishes *The Meaning of Flowers: A Chinese Painter's Perspective* in English and in French.

More information on the author's work can be found at www.franceart.info

With the painter Zao Wou-ki.

TITLES OF WORKS

ACKNOWLEDGMENTS

I dedicate this book to René Percheron, lecturer and author of *Matisse, de la couleur à l'architecture,*

and to Maurice Perrier, artist and writer.

These two friends, both recently departed from this world,

appreciated and supported me throughout my painting career.

All my gratitude to Claudine Tran, Michèle Fallara, Cuc Hoa Tran,

Luce Loussouarnn, Richard Fonti, and Michèle Pentolini.

They all offered me, in their own special way, precious help with the compilation of this book.

Grateful thanks to Cécile and Karine for the French edition

and to Katie and Jane for the English edition.

Translated from the French by Fui Lee Luk
Copyediting: Susan Schneider
Typesetting: Thierry Renard
Proofreading: Slade Smith
Color Separation: Penez, Lille
Previously published in French as *Fleurs et Symboles*
© Éditions Flammarion, 2004
English-language edition
© Éditions Flammarion, 2004

All rights reserved. No part of this publication may be reproduced in any form or by any means,
electronic, photocopy, information retrieval system, or otherwise, without written permission
from Éditions Flammarion.

26, rue Racine
75006 Paris

www.editions.flammarion.com

04 05 06 4 3 2 1

FC0459-04-IX
ISBN: 2-0803-0459-3
Dépôt légal: 09/2004

Printed in Spain